Constructing the Fair

PLATINUM PHOTOGRAPHS
BY C. D. ARNOLD
OF THE WORLD'S
COLUMBIAN EXPOSITION

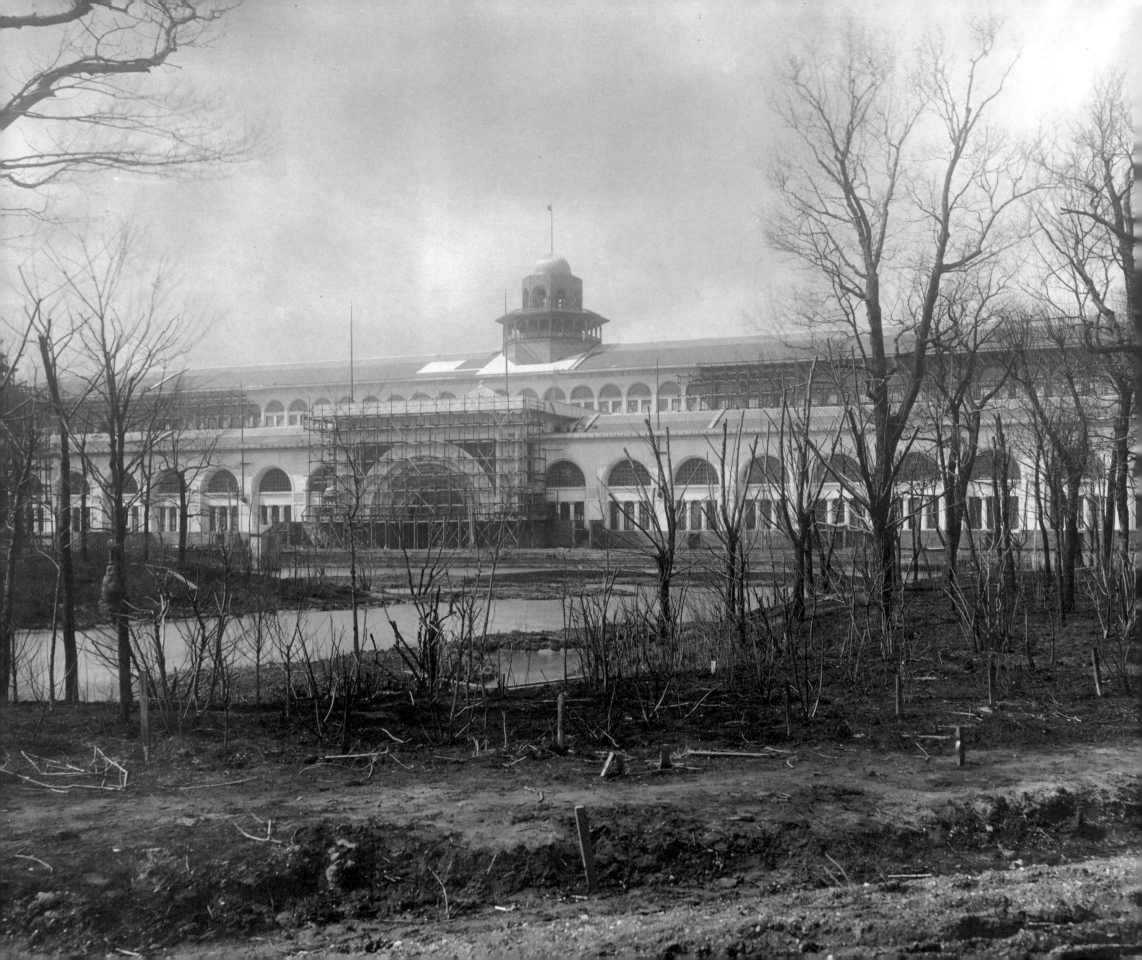

Constructing the Fair

Platinum Photographs by C. D. Arnold of the World's Columbian Exposition

PETER B. HALES

THE ART INSTITUTE OF CHICAGO

This catalogue has been published in conjunction with the exhibition "Constructing the Fair: Platinum Photographs by C. D. Arnold of the World's Columbian Exposition," organized by The Art Institute of Chicago and presented May 1 to July 5, 1993.

Edited by Robert V. Sharp
 Associate Director of Publications
Designed by Joseph Cochand
 Senior Graphic Designer
Production by Katherine Houck Fredrickson
 Senior Production Manager,
 assisted by Manine Golden

Typeset in Caslon 540 on a Macintosh IIci
Printed by Rohner Printing Company, Chicago

Note on the photographs: All photographs in this book, with the exception of fig. 3, are by Charles Dudley Arnold. All photographs, with the exception of fig. 4, are in the collection of The Art Institute of Chicago. Construction photographs of the World's Columbian Exposition were numbered and inscribed by Arnold; wherever possible, Arnold's reference numbers and inscriptions have been used verbatim as the titles of his photographs in both the text and the captions. In instances where Arnold's photographs were not inscribed, brief descriptions have been supplied to identify the buildings depicted.

FRONT COVER AND INSIDE BACK COVER:
16. Lagoon Looking East. July 18. 1891
(detail)

BACK COVER AND INSIDE FRONT COVER:
Court of Honor, looking north (detail)

FRONTISPIECE:
294. Transportation b'l'd'g from the Island.
April 21. 1892 (detail)

LIBRARY OF CONGRESS CATALOGING-IN-PUBLICATION DATA

Hales, Peter B. (Peter Bacon)
 Constructing the fair: platinum photographs by C.D. Arnold of the World's Columbian Exposition / Peter B. Hales
 p. cm.
 "This catalogue has been published in conjunction with the exhibition "Constructing the fair:..." organized by The Art Institute of Chicago and presented May 1 to July 5, 1993" —T.p. verso.
 ISBN 0-86559-112-1
 1. Arnold, C. D. (Charles Dudley), b. 1844 —Exhibitions. 2. Photographers—United States—Exhibitions. 3. World's Columbian Exposition (1893 ; Chicago, Ill.)—Exhibitions. 4. Architectural photography—Illinois —Chicago—Exhibitions. 5. Photography —Printing processes—Platinotype—Exhibitions. 6. Chicago (Ill.)—History—1875- —Sources—Exhibitions. 7. Art Institute of Chicago. Ryerson Library—Exhibitions. 8. Burnham Library of Architecture— Exhibitions.
 I. Arnold, C. D. (Charles Dudley), b. 1844. II. Art Institute of Chicago. III. Title.
TR647.A74 1993
779'.477311—dc20 93-10488
 CIP

Foreword and Acknowledgments

One hundred years ago the world came to Chicago to see the White City in Jackson Park. This now-mythic event, the World's Columbian Exposition of 1893, has resonated in the American consciousness for exactly a century. A physical legacy of that ephemeral World's Fair is the Art Institute's own Allerton Building, which was built to house the meetings of many learned societies held in conjunction with the Fair and then turned over to the Art Institute as its permanent home.

We are pleased to mark the centennial of the Fair and of our building with an exhibition of the extraordinary photographs of Charles Dudley Arnold, who was hired as the official photographer of the World's Columbian Exposition by its Director of Works, Daniel H. Burnham. Arnold's platinum prints were taken as the Fair rose from the swamps of Jackson Park, and they document the astonishing feats of construction from the summer of 1891 to the opening of the Exposition on May 1, 1893. Additional photographs show the Fair and the Midway during its six-month run and further images capture the desolate mood of decline after its close. We are grateful to Professor Peter B. Hales for his close and illuminating reading, individually and collectively, of the more than seven hundred photographs by C. D. Arnold in the Art Institute's collection. These images, which are both document and art, resonate in the mind's eye, as well as on a gallery wall. They take us very near the actual experience of visiting the Fair.

The original massive albums of photographs are now in the Art Institute's Ryerson and Burnham Libraries, where they provide an invaluable addition to the personal and family papers of Daniel H. Burnham, founder by bequest of the Burnham Library of Architecture in 1912. We offer our appreciation to the donors who made this acquisition possible: Dr. Richard E. Buenger, George Edson Danforth, the Friends of Ryerson and Burnham Libraries, Charles C. Haffner III, the Reva and David Logan Foundation, Andrew McNally III, Mrs. Roderick S. Webster, James M. Wells, the Charles H. and Mary F. S. Worcester Collection, and anonymous donors. We are also grateful to the Graham Foundation for Advanced Studies in the Fine Arts, which made a grant toward the publication of Professor Hales's essay; to Tom Yanul, who freely shared his vast knowledge of and interest in C. D. Arnold; to Jack Perry Brown, Barbara Korbel, and Mary Woolever in the Ryerson and Burnham Libraries, who have shepherded this collection into the museum and onto its walls; to David Travis and his staff in the Department of Photography, who provided galleries and installation expertise; to Robert V. Sharp, Katherine Houck Fredrickson, and Manine Golden of the Publications Department, who captured some of the magic in Arnold's mammoth platinum prints in this catalogue; and to Lyn DelliQuadri, Director of the Graphic Services Department, and Senior Graphic Designer Joseph Cochand who designed the catalogue and the exhibition.

James N. Wood
Director

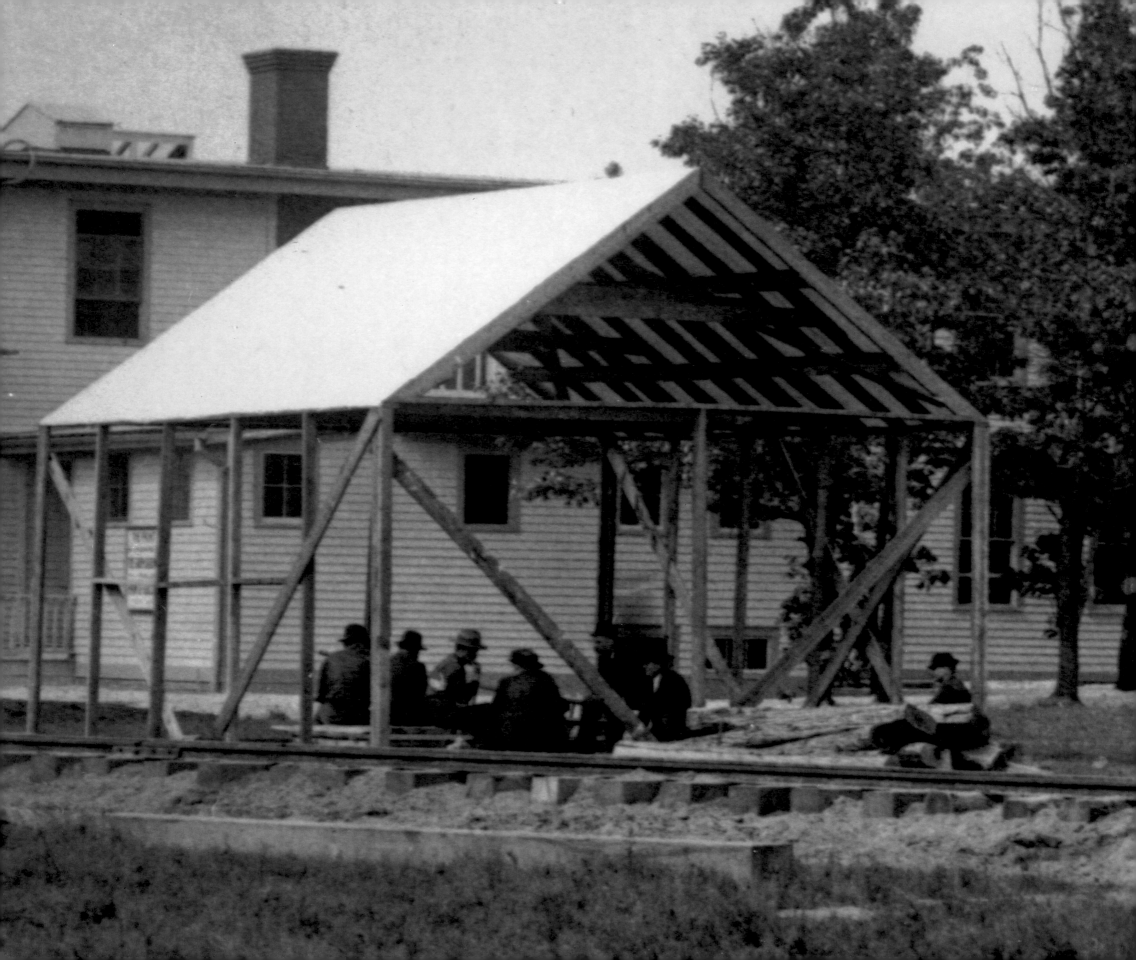

ometime in June of 1891, a man described by one of his detractors as "an obscure Buffalo photographer of no successful business experience" made a small view of a rather homely balloon-frame building, and the open-walled, half-finished structure in front of it, under whose canvas roof six men sat shaded from the brilliant, hazy sunshine (fig. 1).[1] Both buildings lay in a scrubby landscape; in front of them ran a temporary rail line. The light was hazy, the men a bit awkward, and the foreground was a barely differentiated mass of dirt, scrub, and weeds.

Seen alone, the photograph seems little more than a casual "snap-shot," made, perhaps, by an amateur photographer using one of George Eastman's "Kodaks." But this picture was not alone. Rather, it was the first in an extended photographic narrative, meant to investigate, describe, and commemorate the creation of one of America's most grandiloquent and self-revealing cultural artifacts: that carefully planned walk-through museum of modernity known as the World's Columbian Exposition of 1893. Unassuming though it might have seemed, the building it commemorated was the first to be constructed on the fairgrounds that would come to be known familiarly as the White City.

The photographer was Charles Dudley Arnold. His picture of the construction office building, numbered and inscribed simply *1. June 1891*, opened a set of photographs comprising more than 400 construction views that the photographer would make over a nearly two-year period, under a contract to the Columbian Exposition's Director of Works, the Chicago architect and city planner Daniel H.

Burnham.[2] Although he would later be known as one of America's premier city planners and a central figure in the City Beautiful movement, at the time of the Exposition's planning Burnham was a partner in the prominent Chicago architectural firm of Burnham and Root. Burnham wanted, in his own words, "a photographic record… kept…from the start showing every condition of the Exposition to its completion, and this too in all parts."[3] Arnold's photographs would serve a multitude of purposes: they would go to the architects and designers, "aiding them in forming their plans," as Arnold told a newspaper reporter in 1898.[4] They would serve as evidence that the Exposition was living up to its promises to the U.S. Congress, made when Chicago won the competition to hold the Fair. They would grace reports and administrative documents. And, beyond that, they would be released, in one form or another, in a vast outpouring of public documents concerning the Fair, its progress, and its final, shimmering reality.

These construction photographs would eventually find themselves bound to a second series, a group of nearly 300 "official views" of the Exposition, to form an authorized record of the Fair, from its first building to the days just before the great fires that swept through the White City in 1894, destroying what Exposition President Harlow N. Higinbotham called "the fairest dream of civilization." The resulting body of Arnold's work (Burnham would later report that Arnold and his assistants made "about 15,000 negatives" in all) formed the basis for one of the most extensive applications of photography to the marketing of ideas. His photographs constituted the most comprehensive and widely seen vision of the White City, itself a visionary event, for they reached as many as twenty million viewers throughout

PRECEDING PAGE

1. June 1891 (detail)

(Construction office

building).

America and beyond. In their own way, they were more pervasive, more influential, and more permanent than the White City itself.[5] Arnold's pictures appeared in official histories, guidebooks, gravure portfolios, and halftone subscription sets, and as illustrations to articles in numberless journals, magazines, and newspapers throughout the world. They were sold at the Fair as slipshod, card-mounted albumen prints and as elegant, shimmering platinum prints, including some panoramas so large that they are best measured by the foot. They also formed the basis for a limited number of sets of huge leather-bound albums of the construction and the Fair, edited and sequenced by the Exposition's Director-General, George R. Davis.[6] In 1989, three oversized albums containing over 400 construction photographs and 300 finished views were acquired by the Ryerson and Burnham Libraries of The Art Institute of Chicago; this essay is based upon the platinum photographs contained in these albums.

It is today generally conceded that the World's Columbian Exposition was most important not for its physical presence, nor for its architecture, nor even for the way it reflected the particular moment of late-nineteenth-century American culture, but for the utopian image it developed, materialized, and disseminated during the years between 1891 and 1894, an image focused on the interwo-ven destinies of American and global civilization, and the place of urbanism and urbanity within that civilization. More than a World's Fair, the Exposition was, quite boldly and self-consciously, an attempt to persuade American and global audiences of the benevolence, and the price, of progress. It was, as the subtitle of one of the more elaborate volumes described it, a "Display made by the Congress of Nations, of Human Achievement in Material Form, so as the more Effectually to Illustrate the Progress of Mankind in all the Departments of Civilized Life."[7]

Not just the host, but the dominant force in this "Congress of Nations" was to be the United States. Dedicating the Fair, Director-General Davis spoke directly to the nationalist undercurrent of the event. The Exposition was, he said, "an occasion…preeminent in the progress of universal affairs," but one of its lessons was "the pride and satisfaction with which…the citizens of our common country…may…study the historic steps by which our people have been led to their present exalted position."[8] Divinely chosen, Americans now took the center of a global stage, and the Fair was evidence that they deserved this place.

In this quasi-religious aura of divine messages, of revelation and reward, each building of the Exposition, each exhibit therein, and each object within each exhibit served as symbol. A shock of wheat in the Wyoming Building reminded visitors of the biblical harvests they refigured. In the White City, architecture was symbolism made manifest. The picturesque landscape of Wooded Isle was a place not simply of delight but of education as well: it reminded visitors of the historic conflict between nature and civilization, just as the sublime civility of the Court of Honor testified to the final triumph of civilization in the New World.

In America, this type of symbolic discourse had traditionally been the province of words—of sermons, essays, and orations. But the end of the nineteenth century saw a change, a shift in rhetoric to more democratic and more accessible media. The White City exemplified and accelerated this trend. Words still had their place; they overflowed from the Fair, hundreds of thousands of words associated

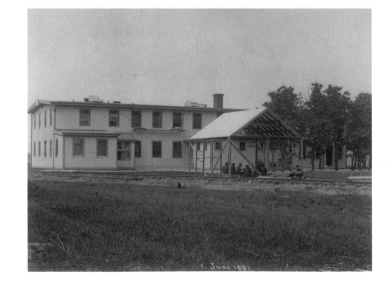

Fig. 1.

1. June 1891

(Construction office building).

with its inception, construction, presentation, and destruction. (Chauncey Depew alone spoke for well over an hour at the dedication, and he was only one of eleven speakers. H. H. Van Meter wrote an elegiac poem to eulogize the final conflagration.)[9]

Yet in the end it was buildings that embodied the White City's visionary utopianism, and pictures that communicated those messages. The heroes of the Fair were not philosophers or orators or politicians; the World's Columbian Congresses, devoted to "subjects of the utmost import," from history to philosophy, from art to evolution, drew the professionals in their fields, but it was the buildings and grounds that attracted as much as a tenth of the American population, and an estimated fourteen million visitors from around the globe.[10] They came not to listen or to read, but to see. They came as witnesses and spectators to a vast utopian city, the realization of John Bunyan's "celestial city" (from *The Pilgrim's Progress*), a heavenly vision whose archangels were architects. These architects, the celebrity names of Gilded Age building arts, accepted as their due the mandate to make a sermon of the eye. Translated from their blueprints and renderings, the White City became a work of visual rhetoric, fabricated to be seen, to be consumed by the eye, not read but witnessed.

"Order is Heaven's First Law," wrote Henry Van Brunt, architect of the Electricity Building. Architects were the visionaries of the Exposition; they dominated the entire enterprise, and their productions were the boldest and most conscious invocations of the myths and ideals the Fair was meant to embody and to teach. The planners and architects striving to synthesize past and present looked first to classicism. The Exposition would revive the ideals of Greece and especially Rome, with its emphasis on centrality of power, a politics of the elite, and a society based upon deference and obedience. But their model was also the Renaissance; they saw themselves as modern-day Albertis, reinvigorating the past with the present, and disciplining the present with the orderly propriety of the past. In those past moments they saw precedents for their ideal *polis*—but they also saw the means to unify and order the vast enterprise of the

154 THE WORLD'S COLUMBIAN EXPOSITION.

aldine and some engineers. The Chief of Construction had sleeping quarters there, and he and his chief men spent a night or two a week there from the time it was ready until the spring of 1892. Mr. Geraldine lived there constantly. The Construction Staff at this time took their meals at the old Park Farm House, in which Mr. Geraldine had placed Edward Jackson, janitor of

AN ARCH JOINT, 225 feet from the ground, in the Manufactures Building, April 30, 1892.

the Service Building. This structure was erected May 1, 1891, and was torn down a year later to make place for the new Service Building.

The actual beginning of the work was the grading and dredging, and ground was first broken on the south line of the Agricultural Building by a force of the contractors' men. The grading and filling was done by means of scrapers where the earth was above water. When the excavation was under water it was all done by great steam dredges that cut their way in from the lake, making channels through which they themselves could float. They were like large beetles, burrowing in the ground, and seemed, as one watched them, like living creatures gnawing away the crust of the earth. Nor were men alone of this impression. A terrier dog spent an entire day fighting a dredge on the Grand Basin, running under and shrilly objecting to the ladles filled with clay as they were swung over the dump, and even fol-

CONSTRUCTION. 155

lowed up the mounds thus formed, biting the iron bottom of the scoop, and then chasing it back again into the water, under the evident impression that the thing was conquered, until another load arose from the water, when he repeated the operation. The trees were cut down with saw and axe, their roots were pulled up by chains and teams of mules, and the wood was piled and burned. During the dredging and filling, McArthur Brothers,

NORTH END OF THE ELECTRICITY BUILDING, APRIL 26, 1892.

the contractors, lodged their men and teams on the grounds, in tents and shanties put up for the purpose, some of the men finding quarters in the Commissary Building, on the Lake Front. The McArthur contract was let by the cubic yard, the price varying with the sort of work to be done. The contract was signed February 18, 1891, and the actual work was begun February 11 with a force of fifty Italians. During the execution of this work, six hundred men, three hundred cars, one hundred and seventy-five teams, one hundred and thirty scrapers, and six dredges were employed. Supplementary contracts for lesser parts of the work were let to N. G. Dodge and James McMahon. The dredges placed the sand excavated from the lagoons, channels, and basins on the banks of the lagoons, whence it was lifted and distributed to the higher levels of the terraces or building sites. Around the formal canals and basin the docking was formed by driving

Fig. 2.

Fair, while keeping architecture at the center. The style in which they embodied their hope was neoclassicism, an American Victorian conception of a fantastical Golden Age now transported, by the power of ambition and money, from the past to the present and from Europe to America. (The poet Richard Watson Gilder, reading a poem to honor the architects at a banquet in New York in 1892, invoked this comparison: "on the New World's breast...Greece flowers anew, and all her temples soar!")[11]

The White City was, in its largest panorama, a model for the apotheosis of the modern city, signaling its conversion to a place of purity, of aesthetic perfection, of urbanity without dirt, disorder, poverty, dissension, or contrast. Beneath each gleaming airy neoclassical facade lay a superstructure of modern engineering—gigantic iron frames borrowed from railroad sheds and stations and from the huge factories that produced locomotives and reapers, and would soon make automobiles and airplanes. Inside the White City's buildings, where this superstructure showed boldly, acres and acres of manufactured goods, from every city and state in the nation and from most nations on the globe, were piled one upon the other in mock-architectural displays—*palazzi* of corn, cathedrals of canned goods.

Rossiter Johnson, ed., A History of the World's Columbian Exposition Held in Chicago in 1893 (New York: D. Appleton and Company, 1897), vol. 1, p. 154-55, with photographs by C. D. Arnold.

The scale of the enterprise alone guaranteed that the White City would be a place of vistas and impressions and not (as some had hoped) a place of learning and thoughtful debate. When the guidebooks recommended a month to see the Fair's entirety, they pretended that there were those who could afford such a hiatus from everyday life, and would use it in the most disciplined and sober of ways. Most visitors had a few days or a week; most of them found their longing for learning soon sated. (Clarence Day spoke of the way that guidebooks and exhibits quickly caused an undeniable urge for German lager at the beer garden on the Midway Plaisance.)[12]

When they had completed their tour, visitors turned to a profusion of substitute forms of the Fair, all of which offered remembrance and recapitulation of the lessons of the Exposition. One of the

measures of the White City's success as a proselytizing tool can be found in the demand for ways to make the vision last, and for ways to extend its reach to those who could not see it firsthand. Something close to four million guidebooks, viewbooks, and souvenir volumes were sold, to be seen by as many as twenty million consumers as they were passed from hand to hand in every city, town, village, and hamlet in America and many more throughout the globe. These artifacts were, in conception and in effect, transportable reproductions of the Fair experience—loaded with word-pictures, drawings, engravings, paintings, and photographs that strove to replicate the very vistas and vantage points characteristic of the typical visitor's experience. And virtually all of these images were based upon the photographs of Charles Dudley Arnold (fig. 2).

Rich as they are in details about everything from the construction of architectural ornament to the effect of windstorms on the half-constructed frames of Machinery Hall, these photographs are more than documents of the White City and the process of building it. They are, themselves, constructions of the Fair: complex parts of a complex attempt to determine the meaning and significance of this vast public utopia, and then to communicate that significance to a wide variety of audiences, from the dignified, self-declared members of "the greatest meeting of artists since the fifteenth century" (as one of their own, the sculptor Augustus Saint-Gaudens, called the architects and artists, to their faces), to the hopeful millions who sought in the Exposition a narrative of their own futures, in America and throughout the world.[13]

Though not a celebrity, C. D. Arnold was by no means the "obscure Buffalo photographer" described by his critics. Had that been the case, he would never have been hired, for his employers were architects, builders, and city planners, and photography was an established tool in those professions. A field awash in conservatism and obsessed by emulation of older forms, American architecture of the Gilded Age needed accurate renderings of those antique models from which to devise its own pastiches, and

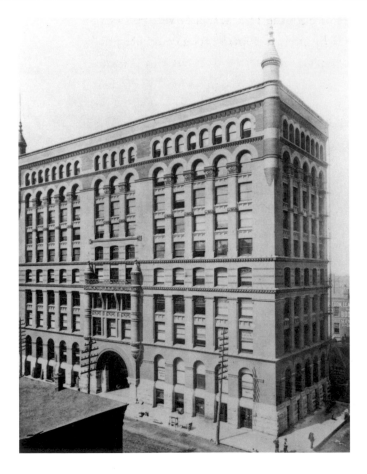

Fig. 3.

Burnham and Root,

Insurance Exchange

Building, Chicago; from

The Inland Architect and

Builder 5, no. 6 (July

1885), unnumbered plate.

photography had recently come into its own as the most satisfactory means to that end. Photography was also the prime medium for promotion of the city-building disciplines. Since the development of high quality mass-output gravure reproduction in the early 1880s, delicate, respectful photographs of individual buildings had come into fashion in journals like the *American Architect and Building News* and *The Inland Architect and News Record*. The very first of these in *Inland Architect*, in fact, was of Burnham and Root's own Insurance Exchange Building, published in July 1885 (fig. 3).[14] As rich, gold-toned albumen prints and, more recently, delicately subtle platinum prints, architectural "views" had also come to serve as seductive substitutes for the original buildings, filling the walls and the files of architectural offices, to be presented when clients sought evidence that they had come to the right place. And when it came to choosing the photographer to make these views, prominent architects were very careful indeed.[15]

For the principal New York firms who made up a major portion of the Fair's architectural roster, Arnold was a solid choice. A Canadian by birth, he had come to the United States at the age of twenty and taken up photography as a profession soon thereafter, settling in Buffalo but expanding his practice throughout the region. In the 1880s he moved into the production of elegant architectural sample books—*Studies in Architecture at Home and Abroad* was the title of his first. Published in 1881 in New York, this work set the precedent for Arnold's production throughout the decade. It provided American architects with exquisitely rendered replicas of European architectural details from which they might derive their own work, and it presented the best of American architects to their peers (fig. 4).

Arnold's first book also sold the photographer to his clients. To make his European views, Arnold toured the English and French countryside with a "dog and cart," selling the resulting photographs "to architects in search of ideas," as one reporter wrote. By 1887, he had earned a medal for architectural photography and by 1888 had established a second practice in New York City, which he maintained until commissioned as construction photographer to the Exposition.[16]

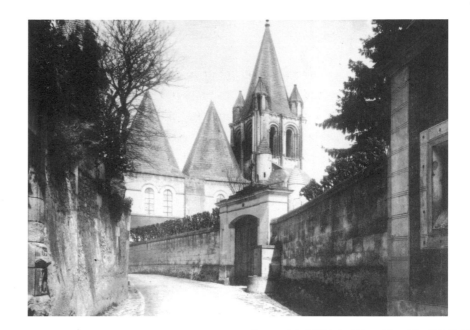

Fig. 4.

St. Ours, Loches, France; from C. D. Arnold, Studies in Architecture at Home and Abroad (Troy, New York: Nims and Knight, 1888), pl. 19.

Arnold's clients may have gained him the Exposition commission, but his willingness to take the task seriously was no doubt influential, as well. To satisfy Burnham's demand for a complete photographic record, the photographer would have to resettle in Chicago for at least three years (Arnold was there for close to four) and make near-daily forays onto the grounds, keeping track of the progress of the site preparation and landscaping, and of each major building as construction moved from foundation work through the final stages of painting and finish work.[17] In addition, Burnham and his associates expected records (or, more pointedly, celebrations) of the major artwork that was to decorate the grounds, cover the building facades, and serve as featured elements in the overall scheme of the Exposition. From the negatives, Arnold was required to supply prints to the Exposition's Department of Publicity and Promotions (run by the Barnum-like Moses Handy), from which they would emanate to all portions of the nation and globe, in one of the first and largest blanket programs of public relations in American history. (Handy reported that "scarcely a day passed on which less than 2,000 to 3,000 mail packages, freighted with information, were not distributed from this department.")[18] As part of that campaign, Arnold's pictures went out to newspapers and magazines, to foreign governments, to bonding agencies, to United States senators and congressmen, to potential

Fig. 5.

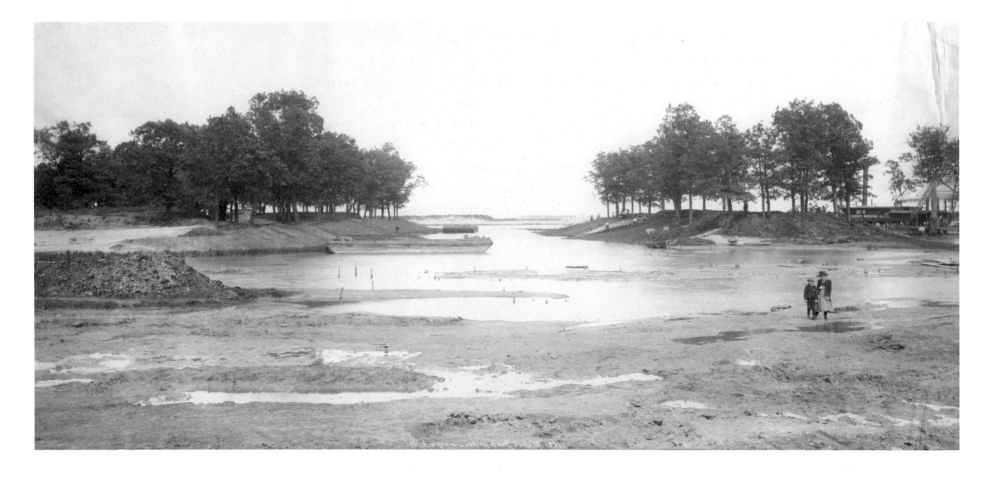

and actual bondholders, and to exhibitors of every type. The endeavor required a large mass-production photographic manufacturing enterprise, with an experienced businessman at the head. For all this, Arnold was probably paid something less than $2,000 a year.[19]

Arnold's capacity to manage such an enterprise was not the prime reason for his appointment. Rather it was his capacity to embody the ideals of the White City in a sophisticated and visually arresting form. A lengthy defense by Exposition President Harlow N. Higinbotham in 1893 made this clear. The Exposition's directors wanted "artistic photographs," reported Higinbotham, and the criteria for determining "artistic merit" came directly from "people well qualified to judge...notably, the different architects who have designed and constructed the different buildings....Mr. Arnold has had large experience, particularly in the line of architectural photography, having been frequently sent to Europe to photograph prominent buildings for the use of architects in New York City."[20]

Higinbotham's defense pointed up one aspect of Arnold's value to the Exposition: his settled position as an intelligent, perceptive, and deferential employee, a man well schooled in the society of architects, builders, and planners, who was able, like a good servant, to understand the desires of employers and anticipate their wishes. But these qualities also altered the nature of Arnold's commission. Burnham may have communicated to Arnold his ambition for the work, his desire for something far more than a simple record of the stages of construction, encompassing the transformation of topography, the engineering feats, and the specimens of neoclassicism that resulted. But in a way he need not have said a word: Arnold already knew what was required.

But knowing is not doing. It is hard to imagine anyone but a highly talented and experienced photographer planning the body of work that resulted from the construction commission. Consider, again, that first photograph, in the context of the first suite of pictures made in June of 1891. For the most part, these were small pictures, in physical size and also in scale. They are unassuming: pictures of the first dredging derricks, of the temporary rail lines, of the tents where workers lived, of the general site areas, of the first rough models for sculpture and architectural ornament. In the three large albums at the Art Institute, they occupy the first three pages. In their sum, they confirm the mundane features of the first picture; they convey an image of a raw, featureless, and unvalued landscape in the first stages of cultivation by human hands.

But at the bottom of the third page is a strikingly bolder and more expansive view. It is a panorama, about 10 by 21 inches, titled *16. Lagoon Looking East. July 18. 1891* (fig. 5). The size alone is a shock after the string of comparatively tiny pictures preceding it. Panoramas of this sort were difficult to make—one either used a sophisticated panoramic camera or (as was probably the case with Arnold) placed a special panoramic back on a large, heavy "mammoth-plate" view camera. Lenses for such cameras were expensive, and maintaining sharpness throughout required that the photographer use a tiny aperture and, consequently, a long exposure time. As a result, a cautious photographer would have chosen moments when the light was strong and the wind low (blurred trees were considered a signal of ineptness), and avoided people. But Arnold chose hazy, overcast light, and he posed two children (always the worst subjects for a long exposure) off to the right, in the middle ground, where no one can miss their importance. Indeed, they gaze shyly back at the viewer, smiling, inviting us to tiptoe through the mud and past the puddles to join them at the edge of the shallow pond that the caption tells us will one day be the Lagoon, a central feature of the Exposition's ceremonial landscape, and the mediator between nature (Frederick Law Olmsted's Wooded Isle) and civilization (the principal buildings that will range across what is now a narrow strip of wooded shoreline). The resulting photograph was technically superb; what is more important, however, is the end to which this technical facility was directed. The picture presents Arnold's first theme: rough nature improved by the hand of man, turned from wilderness toward park, and from desolation toward civility.

Perhaps it is too early to suggest that the children are symbols of the youth of the Fair endeavor, though Arnold's contempo-

Fig. 5.

16. Lagoon Looking East.

July 18. 1891.

Fig. 6.

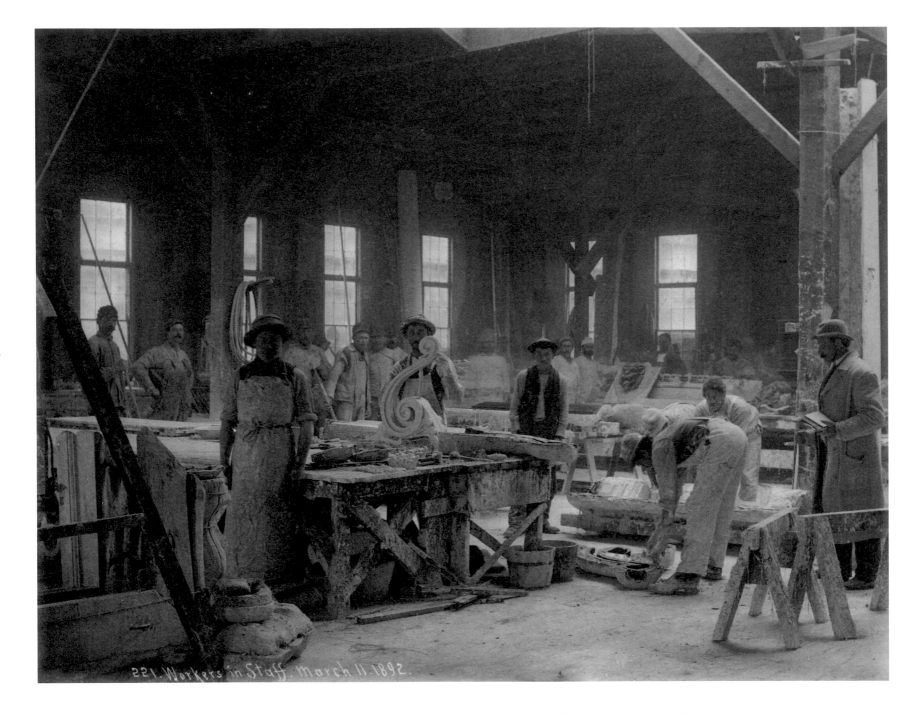

221. Workers in Staff, March 11. 1892.

raries in art photography circles, particularly in Europe, would have leapt to the interpretation. So, no doubt, would the poets and publicists of the Fair at this early stage, men and women who found every opportunity to draw analogies of just this sort in their attempts to render the significance of the affair. Certainly, though, the picture conforms too well to the picturesque landscape genre of its time to call its design coincidence. And this genre is particularly appropriate to the work described by the picture—the conversion of lakefront wasteland into what will be a formal lagoon. But this picture does not really show us the work—that was the place of the smaller pictures that presaged it and that now surround it in the Art Institute's album. Here the dredging barge looks picturesque rather than ugly and serviceable. The entire picture does homage to Dutch landscapes of an earlier era that had inspired some of Arnold's photographic contemporaries like Peter Henry Emerson and Alfred Stieglitz. But Arnold's homage has a different purpose than, say, Stieglitz's—it isn't supposed to advertise the photographer's pretensions to high art, but rather to reassure the viewer, setting the work at the edge of Lake Michigan in 1891 within the visual and historical context of the seventeenth-century Dutch lowlands.

In this respect, the panorama does more than introduce a central theme in Arnold's construction work. It also reveals a fundamental strategy by which he sought to invest the everyday work of construction with weight, and to convey its cultural import by setting it within the context of grand European public works of the past. Like his titular employers, the architects, Arnold had early settled on what might be called a strategy of historical revival.

We can see this even more pointedly in the views Arnold made, virtually from the first, of artists at work. The earliest successful ones are also found in those crucial first three pages of the first album. They tend to be rather drastically reductive: the sculptor appears, dressed in artist's smock and properly arrogant posture, sketching out or meditating on his work, which dominates the center of the picture. They are carefully posed *tableaux vivants*, and they grew better and more historicist as Arnold progressed. These pho-

tographs are drawn from a whole class of genre scenes popular in nineteenth-century academic painting, and also in academic art photography of the time. A few are more compelling: they describe the studios in a more deliberately homely and unassuming manner; details impinge, deferentially, at the edges of the scene, and they give a quality of understated tact to pictures whose implicit function is to heroize the artists (fig. 6).

Arnold's appropriation of historicist styles and references solved a fundamental problem: how to use photographs to document the transformation of the site in such a way that they would not only describe the physical details of construction, but also communicate the underlying meanings and the sense of importance with which the Fair's creators and underwriters had invested the undertaking.

The opening suite of pictures, made in June and July of 1891, suggests that Arnold's strategy was there from the first. The panoramas he made in that first two-month stretch confirm it. Again and again in these pictures, we see Arnold devoting at least a third (and usually half or more) of the stretched rectangle of the picture to dirt, sand, and mud, which are usually punctuated by construction detritus—planks, bits of scrap railroad ties, the deep ruts made by wagons. The actual zone of construction Arnold tended to squeeze into a thin strip in the middle of the picture, in the background, where it is hard even to tell what's going on. A view of the foundation piles for the Woman's Building made on July 20 is typical; without a magnifying glass, it is impossible to tell what exactly is the subject (fig. 7). The only impression Arnold conveys is a general sense of the horizontal expanse that will be taken up by the building. This is a picture of something that hasn't happened yet. A slightly later panorama, titled *29. Electricity Building July 30. 1891*, is even more extreme (fig. 8). But all that's visible here is a collection of lumber piles, the boxcars from which they were apparently unloaded, and the rail lines along which those boxcars ran.

Arnold's solution to the problem of showing something that had not yet occurred was to focus on the homely details in small pictures, and to use the large panoramas to emphasize the emptiness

Fig. 7.

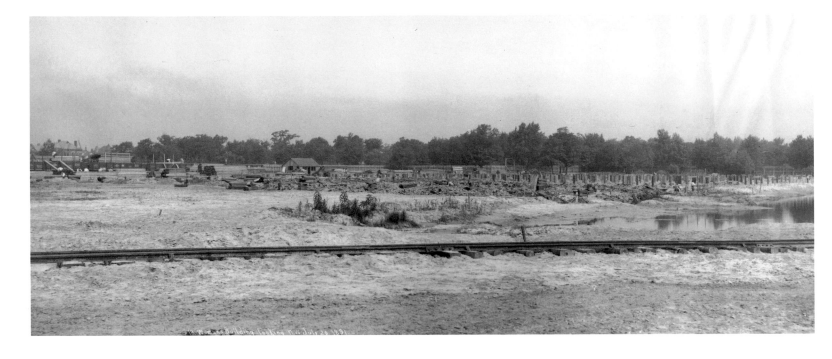

18. Womans Building look-

ing N.W July 20. 1891.

Fig. 8.

29. Electricity Building

July 30. 1891.

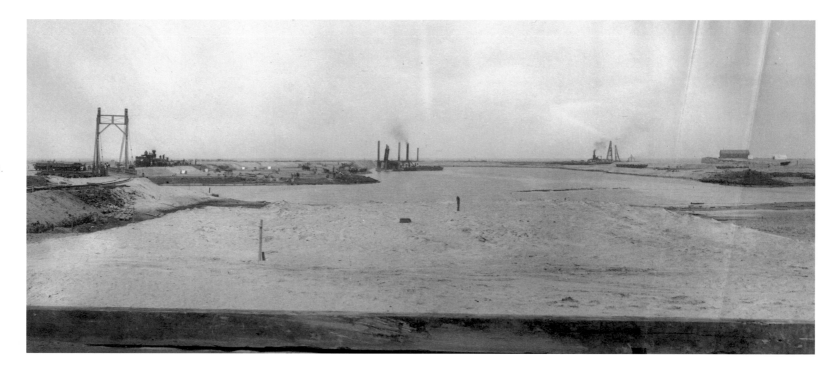

30. The Basin July 30 1891.

Fig. 9.

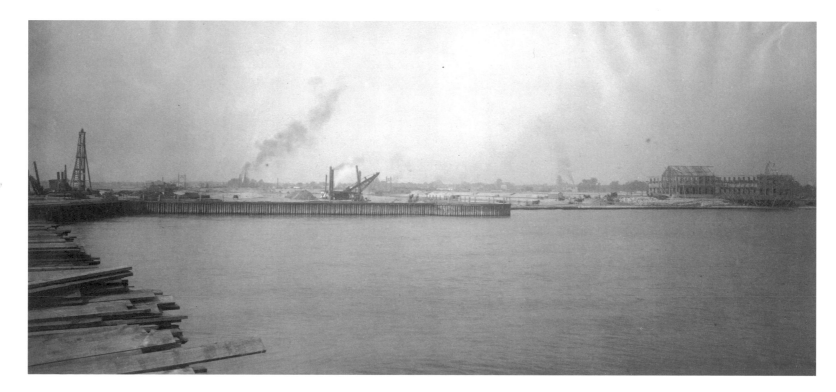

45. Looking West from New

Pier Sep. 1. 1891.

Fig. 10.

of the site.[21] In *30. The Basin July 30 1891* (fig. 9), for example, the foreground is a pair of foundation pilings laid across the length of the bottom edge; the middle ground is a sand pile in which can be seen wagon tracks and even workers' footprints; and the background is blank sky, which serves as the backdrop to delicate silhouettes of temporary bridgeworks, railroad engines, spewing dredges, and minuscule workers.

But Arnold's goal was necessarily radically different—not formalism but narrative, not art but artifice. This provided problems, and we are lucky to have the opportunity to see the photographer groping for solutions and then finding them. In some of these early panoramas, for example, the upper strip of sky and the foreground strip of dirt or water are featureless detractions from the picture itself, though they are essential to the narrative strategy of the larger suite of pictures. (In later views taken from the same vantage points, these spaces will begin to fill with the evidence of construction and then, finally, with the landscaping that signals the scene's complete metamorphosis.) Still another panorama, *45. Looking West from New Pier Sep. 1. 1891* (fig. 10), shows Arnold leaping to use each new feature of the built environment (and the artificially created "natural" environ-

ment) to resolve such problems. Here he set the camera so that the piles of lumber that would be used to plank the pier obtruded into the foreground space, and he chose a still morning when the smoke from the coal-fired steam dredges might lend feature to the sky.

These panoramas, a few whole-plate views, and the small pictures sufficed through the end of October 1891, by which time the panoramas looked far different—they were filling up with the framework for the bottom floors of structures like the Woman's and Transportation buildings (figs. 11, 12). From that point, however, certain developments tempted Arnold to change his picture strategy. The first of these events was the completion of a building tall enough to offer a safe vantage point for the high-angle views that formed a basic part of the repertoire of nineteenth-century urban photography.[22] On October 28, Arnold climbed into the tower of the Fire Engine House carrying his mammoth-plate camera, this time with the full, 18-by-22-inch plate holder. From this vantage point, he made a pair of mammoth-plate views, one looking northwest across unfinished land and water, and the other looking due north. These views offered a new and more substantial means of presenting the fundamental duality that underlay most of the photographs of this

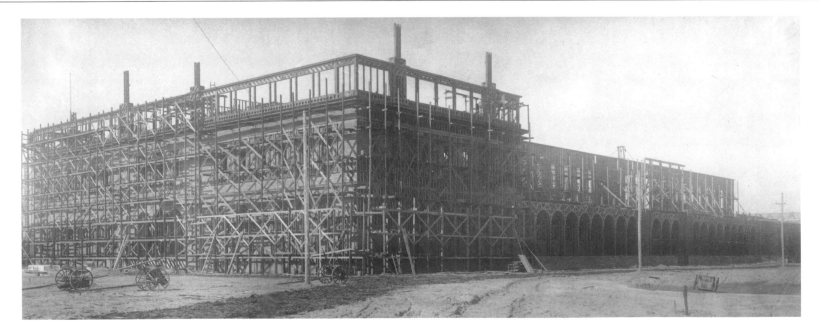

Fig. 11. *74: Womans building looking n.w. Oct. 13. 1891.*

first stage of construction: the contrast between the raw, unfinished work of nature and the steadily encroaching forces of cultivation and civilization. The higher angle of view enabled Arnold to lay out a further stretch of land across the rectangle of the picture space, so that what was only a thin strip of activity in the earlier ground-level panoramas, has now opened up to reveal both physical and symbolic details. In the first of these mammoth-plate views, it is the actual framework for the buildings, both in foreground and in back, that has grown more prominent; in the second, Arnold himself grew more subtle—one can see, on the forested island that will be Wooded Isle, a single white-coated figure tending the new shrubbery (fig. 13).

The other two mammoth-plate views made in late October signalled further opportunities and ambitions. One of them, *95. View from South gallery Mines B'l'd'g Oct. 29. 1891*, used the grand sweep of the mammoth-plate to do justice to the equally monumental spaces being enclosed by the first major building of the Fair (fig. 14). Here the large print served to explain the vast scale of the building enterprise, and the smallness of the figures on the building's floor. The other mammoth-plate took a monumental architectural subject—Adler and Sullivan's "Golden Door" to the Transportation Building

(fig. 15). If the first two mammoths were studiedly picturesque, neatly fitted within the landscape tradition, this one was as studiedly (almost stiltedly) civil, even artificial. From the walkway boundary that began in the lower right corner, swept into midground, then turned to exit on the right, to the three figures posed in the middle, to the welter of construction scaffolding in front of the portal itself, everything was as formal as a still life. Yet each element was also as deliberate, and as pointed. Take, for example, the three figures. As indicators of the scale of the building, one would have been sufficient, and Arnold should have placed him closer to the door. But these figures had other purposes: to announce the artificiality of the picture; to present the three positions of spectatorship—consumer, witness, and tourist, all posed with eyes to the camera. (There are in fact three other people in the view, not counting a fourth who has been excised by motion, blurred out of existence, but these are workmen, high in the structure, barely visible in the hazy, lightstruck upper reaches of the picture. Workers will not appear as subjects in themselves for a number of months.)

These mammoth-plate views completed Arnold's chosen repertoire. By the late fall of 1891, the photographer had set the vari-

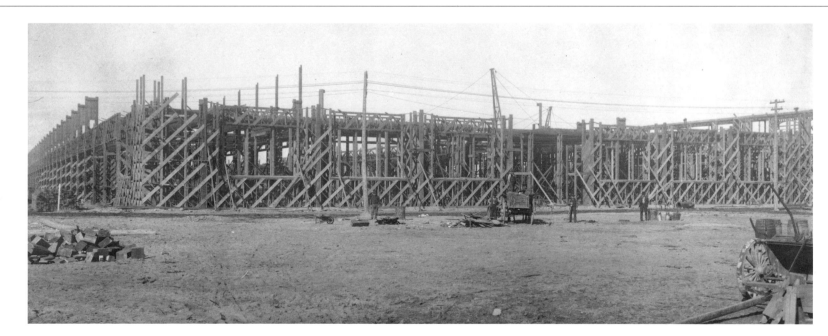

75. Transportation building

looking North Oct. 13. 1891.

Fig. 13.

Fig. 13.

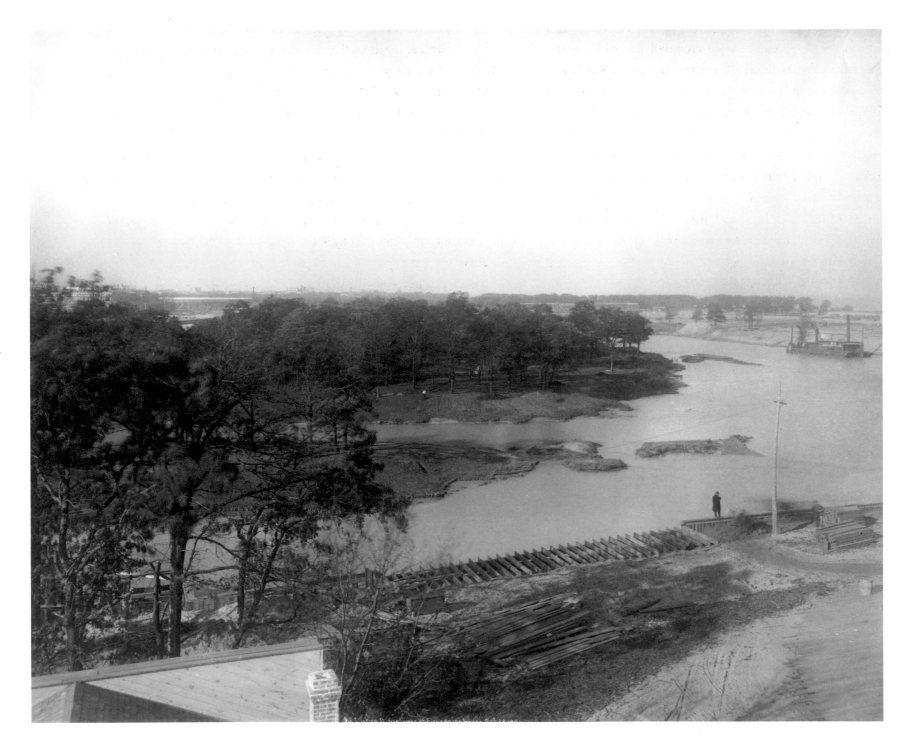

ous elements of his work into place. His small views were systematic, and often, now, their foregrounds were crowded not with natural roughness, but with the roughness of construction itself. His larger, whole-plate views of the artists at work had also grown in ambition. A view he made on October 30 of the sculptor for the Mines Building and his assistants was packed with detail, the frame broken into complex shards, each part yielding something essential to understanding the process of sculptural modeling that the picture describes (fig. 16). The panoramas, too, had changed, as the middle areas swelled with the rising frames of the buildings, and as the foregrounds became more cluttered. The photographer has also shifted his camera to the side rather than photographing straight on, as he had in the understated, transparent first views (fig. 17). And the mammoth-plate views, as we have seen, provided the final and most monumental stamp to the enterprise.

Another view, *103. On roof of Woman's B'l'd'g. Nov. 11. 1891*, drew the disparate elements together and encapsulated this mid-stage (fig. 18). Here the entire enterprise of the Exposition's construction combined to generate a composition of classical stability and monumentality: the assorted debris of the construction process, and the neoclassical glories, halfway between homely grey and their eventual pristine whiteness, halfway between prosaic labor and the blank sublimity of the sky. The mammoth plate and the high angle of view enabled Arnold to set the horizon line so that it bisected the openings enclosed by the columns, so that each aperture made its own picture of the bleak, fall landscape of Wooded Isle and, behind it, the open spaces where the Manufactures Building would eventually go. In the blank whiteness of the platinum sky, the rods that would later support a winged goddess rise from the front colonnade. It is a marvelous picture—alone, as an image whose architectonic monumentality mirrors the goal of its subject, and as the final chord of the opening movement of Arnold's suite of construction views, drawing together the dualities of nature and civilization, potentiality and consummation, that formed the central ideas of the Exposition itself, and defined the narrative of construction.

The winter of 1891-92 was even more brutal than usual, and it came earlier. By the end of November, the fairgrounds were covered in snow; though it melted by the end of the first week of December, builders and planners were forewarned of what they could expect. With construction already behind schedule, work could not stop for the colder months. None of the buildings was fully enclosed, so the usual expedient of heating the interiors and working on them was inappropriate. In some cases the structural ironwork was just about to be erected; in others, the exterior walls were ready for framing; in still others, the process of covering the wooden lath with their finish coverings of "staff"—a relatively impermanent mock-stone made of plaster, horsehair or jute fiber, and cement—had already begun. Outside the buildings, dredging, filling, landscaping, and the like would have to stop, at least while water and ground were frozen. For a few months, then, Arnold had the opportunity to slow his pace and consolidate his position.

The pictures of December, January, and February confirm this. The stark, leafless expanses of grounds and the skeletal structures of half-completed buildings made a good match, as Arnold

PRECEDING PAGE

93. Looking N. from

tower of Fire engine house.

Oct. 28. 1891.

Fig. 14.

95. View from South gallery

Mines B'l'd'g Oct. 29. 1891.

Fig. 14.

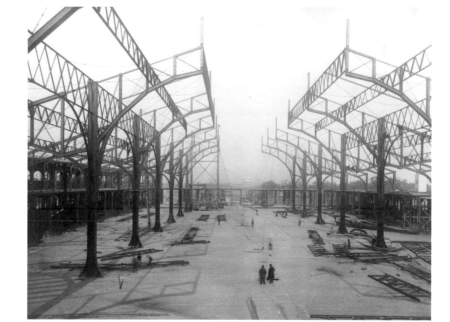

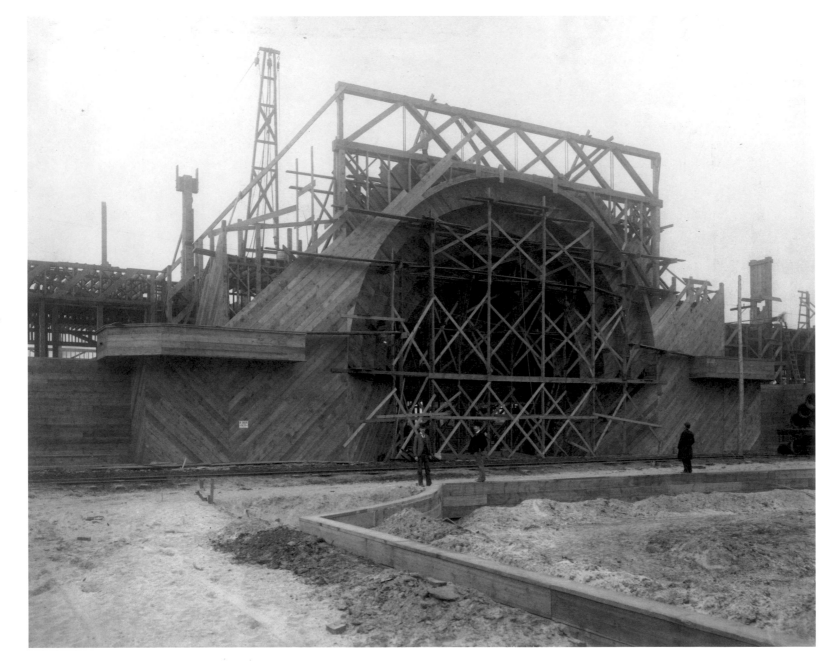

revealed in pictures like *112. Fisheries building looking N.W. Dec. 5. 1891* (fig. 19). Here Arnold's knack for organizing pictures showed itself; the long reach of the foreground's frozen earth he broke up by including the long shadow of his camera and himself, and the twin construction derricks within the open rotunda of the Fisheries Building across the narrow north inlet echoed the pair of stark trees that rose from the ground on his side of the water. Once again, a temporary hut on his left served as counterpoint to the monumental scale of the Fisheries structure across the water.

Many of the views Arnold made that winter focused on the scaffolded exteriors of the buildings nearest completion, like the Mines Building, which he photographed in mammoth-plate, *120. South end of Mines b'l'd'g Dec. 16. 1891* (fig. 21). The scaffolds made for interesting textures; they accentuated the complex play of light on the surfaces where, if one looked carefully, one could see the process of "staffing" taking place, as various architectural ornaments (pediments, arches, cornices, friezes, and more), cast and finished in the sculptural and decoration workshops, were raised up and mounted onto the wooden lath.

It was also during the winter of 1891-92 that Arnold first truly discovered the workers and their labor as the reason for pictures. Workers had appeared in many of Arnold's earlier pictures; but for the first time we can see the photographer actually choosing the workers as subjects. Before, they were merely incidental to the buildings, or the means of defining their scale, or stiff illustrations of the means by which various acts of construction took place.[23]

Perhaps, having determined successful strategies for rendering the grandiose pretensions of the architecture, the photographer now sought and found a new subject to maintain his interest. But a more mundane explanation may simply be their connection to the stage of work and its inherent drama. For on a number of the more architecturally complex buildings, the erection of the structural ironwork had brought forward a new breed of laborer, the ironworker, whose craft had come to symbolize American technological and engineering advances and the courage required to put them into place.

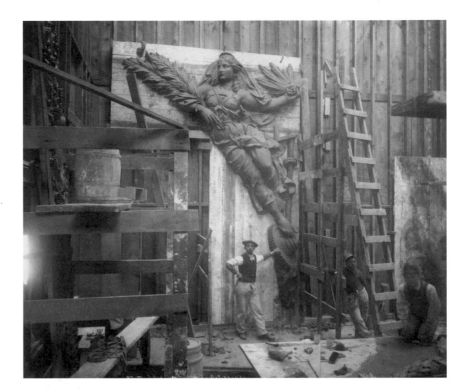

Fig. 16.

The first of these new photographs may have been a mammoth-plate view of the Fisheries Building, done on December 19. This particular effort was less successful than later attempts, because here Arnold seems to have first attempted to pose a large group of workers—in this case thirty-eight—for the slow and cumbersome mammoth-plate camera. Over the next months, Arnold increasingly placed the figures of workers at judicious points in the pictures. In a wonderful view entitled *Raising the derick for iron work. Machinery b'l'd'g Feby 6. 1892,* Arnold seems to have persuaded the workers to stop the hoisting process halfway in order to pose beneath it, in what appears to be the exact spot where the huge derrick would come crashing down were the insubstantial guy wires to fail (fig. 20).

These were transitional images, views of the architecture in which the workers had crept closer and closer to the center of interest. Then on March 24, 1892, Arnold made his first group portrait, in which he portrayed the earth workers on the Midway Plaisance, about sixty-four of them, posed with their horses and earth carts, and every one of them, still and formal, stared straight down the barrel of Arnold's panoramic lens (fig. 22). Some of the workers smile a bit; all

Fig. 16.

97. Model for Mines B'l'd'g

Oct. 30. 1891.

PRECEDING PAGE

81. Main entrance.

Transportation B'l'd'g.

Oct. 30. 1891.

seem aware of this as a serious, a memorable event. (Arnold's camera, huge and unwieldy, and the long exposure, probably helped bring this home.) The picture is by no stretch of the imagination an "architectural view"—the sort of picture for which Arnold had made his name. Instead, this is a photograph of workers, of the equipment they used in their labor, and of the object of their labor: the transformation of landscape, of nature, into something not yet defined.

By the end of March, Arnold had turned a few anomalous pictures into a series, by adding a set of views of individual workmen standing next to their products, and by making a second group portrait, *263. Workmen for Edge Moor Bridge Co. M'f'r's B'l'd'g Mch 30. 1892* (fig. 23). This time, the men scrambled up the girders and stood on the massive beams; silhouetted against the sky, they are as much the subject of the picture as is the ironwork itself.

From this point on, Arnold's construction pictures took on a new theme. When the arches of the Manufactures Building went up, he photographed them with their assemblers perched atop them. In both the smaller and larger views, workmen posed with their equip-

ment—as they did in *267. Hoisting Engine on floor of traveler. M'f'r's b'l'd'g. April 6. 1892* (fig. 24). Partly, we may understand this as a consequence of the immensely more exciting phenomenon of ironwork construction that characterized the spring work on the triple arches of the Manufactures and Liberal Arts Building. After all, this was to be the largest single building in history, with arches that were 368 feet wide and trusses that rose 206 feet in the air. Its erection was endlessly fascinating, not only because of its engineering innovations but also because of the opportunities it afforded for making truly interesting pictures. Two pages of views in the Art Institute's albums—all made in the week of March 21—show this to even the most casual viewer (figs. 25, 26). And the other views on these pages (one of a cut-out for the electric subway, and the another of the site of the fountain at the east end of the Grand Basin) suggest that Arnold could take the more complex and hyperkinetic strategies suggested by the construction of Manufactures and apply them to other places, as well.

Of all the photographs made that spring, quite possibly the finest was the mammoth-plate view *276. First arches M'f'r's b'l'd'g.*

OPPOSITE PAGE

103. On roof of Womans

B'l'd'g. Nov. 11. 1891.

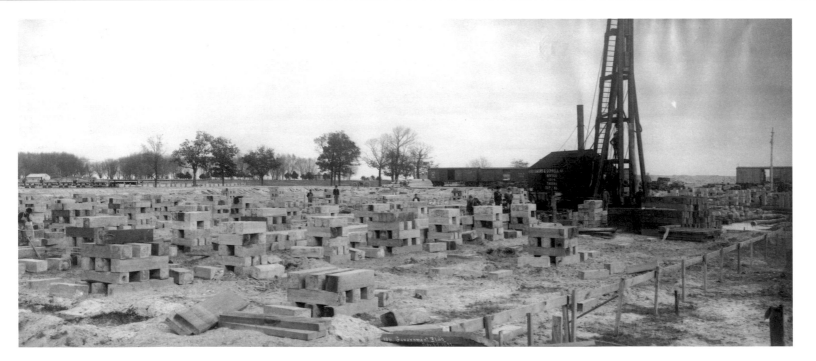

Fig. 17.

106. Government B'l'd'g

Nov. 14. 1891.

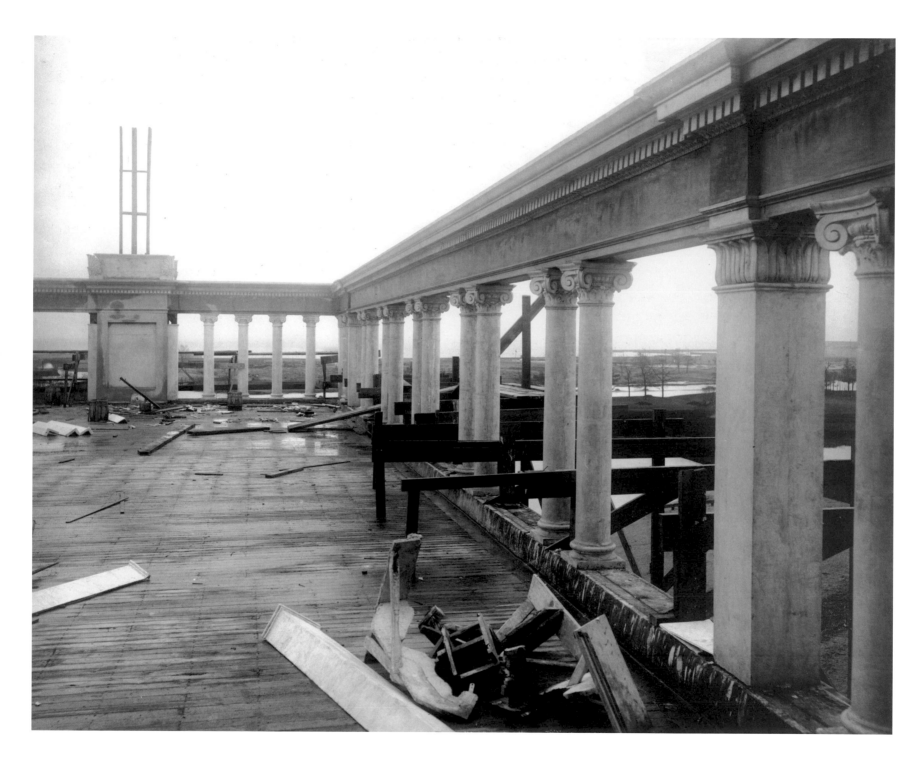

Fig. 18.

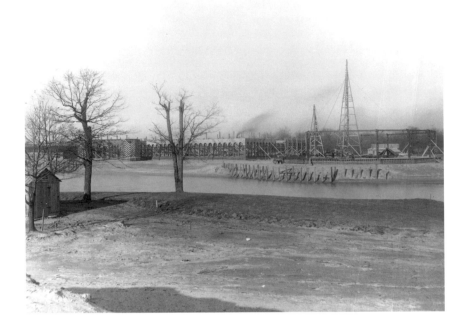

Fig. 19.

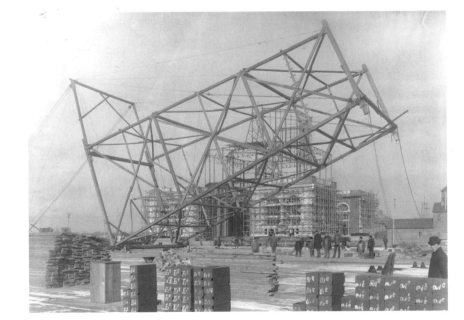

Fig. 20.

April 15. 1892 (fig. 27). Clearly, Arnold certainly thought so, for this is the only view of the more that 400 construction photographs onto whose negative he etched the notation *Neg. by C. D. A.* The picture integrates nearly every strategy Arnold had developed over the past year of work on the Exposition. The foreground is, in one part, empty planking, in the other, a pile of discarded plankwork and used-up shims, many with the bent-over bolts and nails used to hold them in place still visible. In the middle ground is the Edgemoor Bridge Company's construction shack. The wood-frame and plank building appears straight on, so it is as flat as a movie facade or the false front on a saloon in Wyoming. Behind it, the predominating rectangle of sky is filled with the daunting superstructure of the arches and the traveler below it, upon which stand, sit, and lie no less than forty-eight ironworkers, many of them balancing insouciantly, a few even acting out little feats of aerial gymnastics. All of them are looking straight into Arnold's lens, and only one of them is blurred; all have stood stock still while Arnold set up the picture, loaded the plate-holder into the camera, and made the estimated two-second exposure.

After this view, the difference in Arnold's work is quite striking. We can partly account for this by recognizing the fortuitous combination of elements that made it possible. With most of the construction process fully explained in previous views of buildings that had been begun earlier and were thus near completion, Arnold had a double advantage: he could make Manufactures and Liberal Arts his single focal point for construction without feeling that he was slighting the rest of the Fair; and he could work at a more leisurely pace, even to the point of arranging with supervisors and workers for the sort of complicated set-up shots we saw in number 263 (fig. 23).

Naturally, he had the advantage of hundreds of previous pictures from which he had learned lessons concerning the best way to analyze, describe, and glorify the construction process. Pictures like this one consolidated the strategies of so many earlier views: the foreground, cluttered yet functional; the contrasts between the dark bottom of the frame and the lightstruck top; the way his mammoth-plate camera lens rendered the vast open spaces and interwove middle-

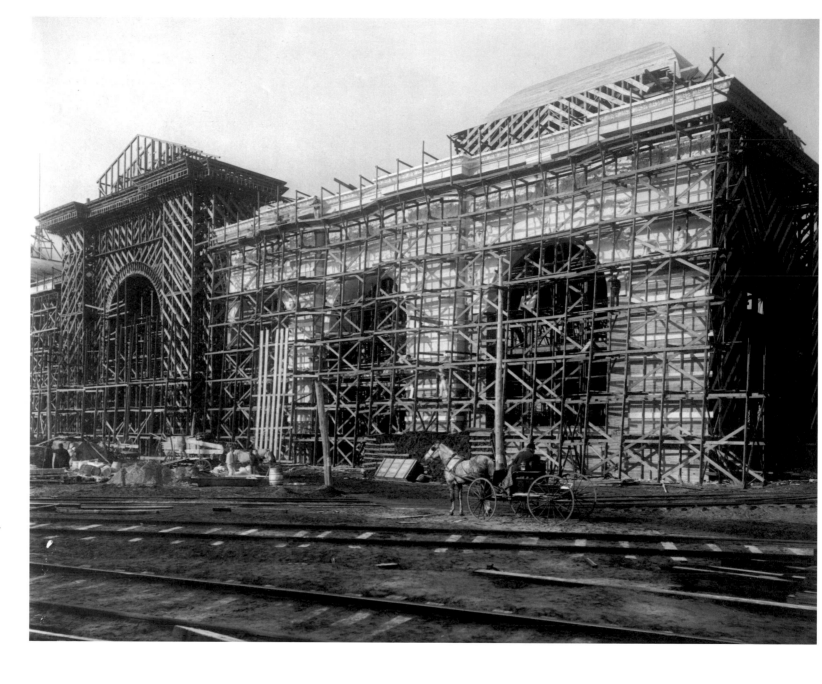

120. South end of Mines

b'l'd'g Dec. 16. 1891.

PRECEDING PAGE

Fig. 19.

112. Fisheries building

looking N.W. Dec. 5. 1891.

Fig. 20.

190. Raising the derick

for iron work. Machinery

b'l'd'g. Feby 6. 1892.

Fig. 21.

ground and background. Even the rudimentary use of silhouettes found in the early construction pictures Arnold had now honed into a telling means of turning light to a new symbolic function. Finally, Arnold could fully exploit the literal scale of the mammoth-plate, so that even the most important elements of the pictures (the cocky, even arrogant ironworker at the top left of this view, for example) could be set far in the background, far from the camera, without disappearing or becoming indistinct. A new city was appearing, designed by Renaissance men and populated by heroes.

As the spring of 1892 turned to summer, Arnold's pictures moved in a new direction. They became, in essence, rehearsals for the "official" views of the completed Exposition that he and his business partner, Harlow N. Higinbotham, Jr., would soon be granted monopoly rights to produce. In view after view, we can see Arnold staking out vantage points that would later become the locations for his most popular and striking finished views. A view of the Fisheries Building from Wooded Isle, made on June 22,

even shows us the spot recommended for the perfect view by the Kodak guide for "snap-shooters" (fig. 28). Indeed, many photographs, like the two made of the Administration Building on May 21 and July 23, respectively, afford us the opportunity to see Arnold moving into an increasingly formal posture. In the first view (fig. 29), a quality Arnold's time would have called "charm" pervades the picture, undercutting the as-yet-uninstalled grandeur that will (by the second picture) emanate from Richard Morris Hunt's ambitious neoclassical building, about which one of the guides to the Fair wrote: "This magnificent structure...the superb creation...dignified and beautiful...[with] its gilded dome...has been pronounced the gem of all the architectural jewels of the Exposition."[24] The foreground of the picture is cluttered with piles of sand, irregular wooden pilings, and a wooden walkway with a rough railing; in the middle ground can be seen a man gazing through a piece of equipment on a tripod—it's not a camera; it's a surveyor's tool. The building's central area, topped by the dome, is still just open framework. Arnold also included the wooden, balloon-frame Fire Engine House, with its vernacular octag-

OPPOSITE PAGE

263. Workmen for Edge

Moor Bridge Co. M'f'r's

B'l'd'g Mch 30. 1892.

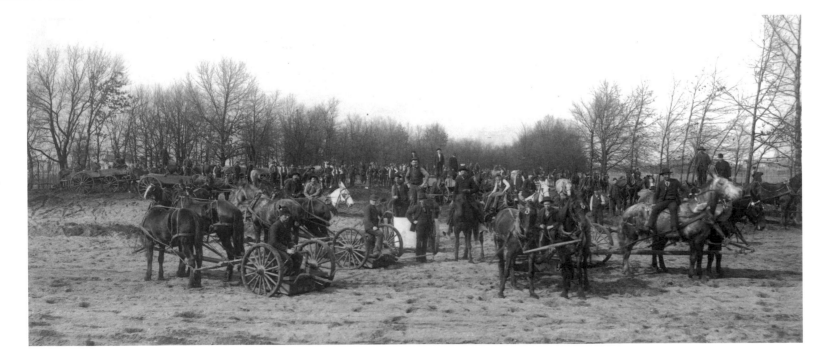

Fig. 22.

254. On the Midway

Plaisance. March 24. 1892.

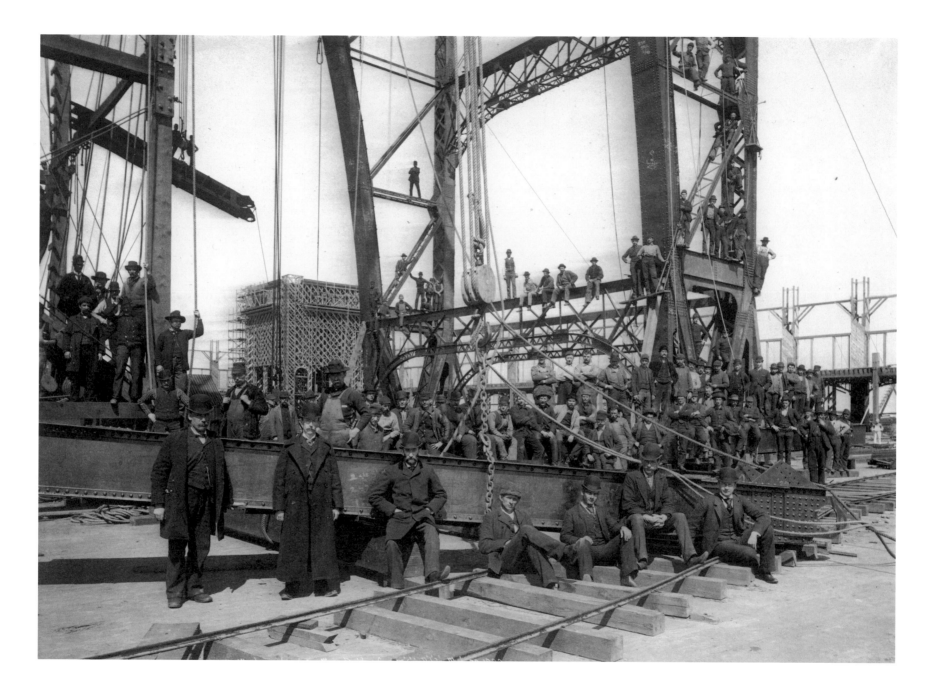

Fig. 23.

onal tower (the very one from which he took his first mammoth-plate views about seven months before). But most striking is the pair of figures who are posed in front of the firehouse, on that walkway in the foreground. They are close enough that we can recognize them: the man is a fireman, in his uniform, and the boy is about eight years old and dressed in relatively fancy garb. (Perhaps he is one of Burnham's two sons, on an outing with Arnold, who had entertained the boys in March by showing them sample pictures and lantern slides that he had made to show the congressional investigating committee that had come to town.)[25]

Compare this view to the one Arnold made two months later, from a point about one hundred yards farther back, along the same angle of view (fig. 30). This image is far more formal, more evidently a part of the Arnold strategy of setting construction, potential, or human activity in the foreground or to the sides, and putting the sublime building in the center where, lightstruck and shimmering, it could almost fade into the whiteness of the sky. This would become Arnold's strategy in nearly every picture he made of the finished buildings. The step backward from the first to the second picture characterized his movement during the summer and fall, as he prepared to make, and even produced, early versions of the official views.

He did this, for example, in seeking the ideal vantage point from which to encompass the gigantic finished structure of the Manufactures and Liberal Arts Building. As this building neared completion, and perhaps more importantly, as the landscaping surrounding this and the other buildings reached a stage that allowed him to determine where the walkways would be, Arnold began to experiment a bit. He made his first big view of Manufactures from the roof of Machinery Hall (fig. 31), a marvelous view, particularly as a platinum print, in which the buildings, the waterways, the dirt, and the sky are all presented in plays of highlight. The rostral column upon which would sit Johannes Gelert's statue of Neptune was still surrounded by supporting scaffolds, and it rose up in the foreground center, a close-up reminder of the basic building blocks of the Fair. The column seems almost to support the still skeletal form of Manufactures. This view would later appear as an official image, though Arnold would move to the left corner of Machinery Hall, and would use a lens with a much wider angle (fig. 32).

By September 1, 1892, Manufactures had been effectively completed, and this time Arnold moved his camera back down to the ground in search of another appropriate vantage point (fig. 33). Neptune's column was too obtrusive from this position, so Arnold moved to the left of it, and it disappeared from the picture, though its corresponding column across the Basin then appeared, much diminished, on the left end of the frame. In its place at the center was the recently plowed dirt circle for what would become one of the fountains. This picture thus recapitulated Arnold's oldest trope: potential at the bottom and in the foreground; gleaming civilization above and to the rear, fading into the sky.

But this was a theme appropriate only to the construction views. For the official equivalent, made probably in the spring of

Fig. 24.

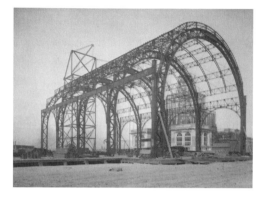
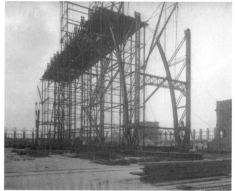
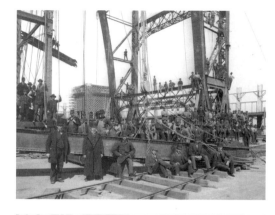
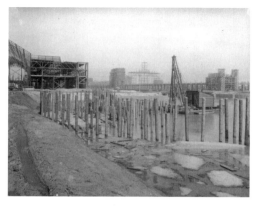
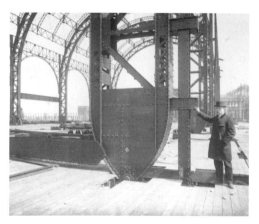
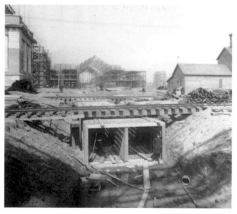
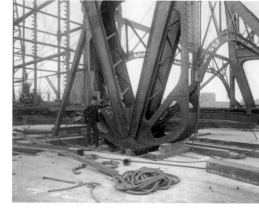
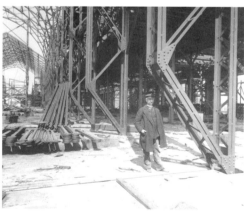

Fig. 25

Construction views,

March 21-26, 1892.

Fig. 26

Construction views,

March 25-30, 1892.

Fig. 27.

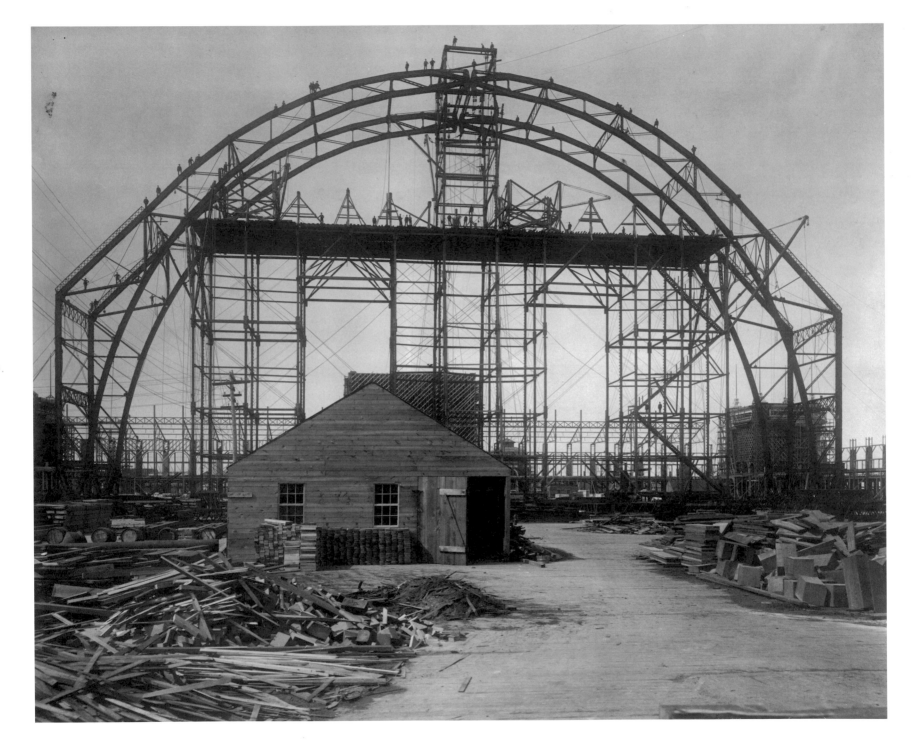

1893, Arnold returned Neptune and his column to prominence, moved up to the balcony outside the second floor of Machinery Hall, and produced a compromise (fig. 34). The result was among his finest formal views, one that would appear in virtually every guidebook and portfolio released by the Photography Division.

Views of the finished White City would have to contend in one way or another with the presence of people. Workers had entered the pictures as dramatic presences in the winter and spring. In the summer, visitors made their appearance, on the grounds and in the pictures. As the weather became fine and the muddy grounds dried up and began to take on a landscaped appearance, it became a fad for Chicagoans and their visitors to seek permission to enter the grounds and wander about. Construction was so popular, in fact, that Moses Handy published a guidebook in August 1892 for those who wished to see the progress. Titled the *Official World's Fair Guide, Map and Directory, During Construction*, printed and distributed by Rand, McNally and Co., it sold for ten cents. It was illustrated by engravings of artists' sketches of the completed buildings and grounds. Tourists

armed with the guidebook had an easy time getting to the fair-grounds. By that summer, the Illinois Central Railroad was running trains every twenty minutes and charging twenty-five cents round trip; boats on the lakefront landed at the Exposition pier at 63rd Street for the same price.[26]

Once they arrived, visitors had the opportunity to see first-hand most of the stages of construction. As of July 1, 1892, the Mines Building was virtually complete; the towers for the Electricity Building were framed out, and their wooden superstructures awaited cladding with staff. The Fisheries Building, too, was substantially complete, though workers clung to the roofs and scaffolding hugged the central dome-like tower. The arches of Manufactures, however, were still in the process of erection in mid-June, and by July 1, a visitor could look across the Lagoon at the Mines Building's facade, Electricity's towers, and the railroad-shed superstructure of Manufactures, and see nearly every stage of construction (fig. 35). For devotees of modernity and progress, even more spectacular was the view of Machinery Hall from the southeast (fig. 36). There the arches

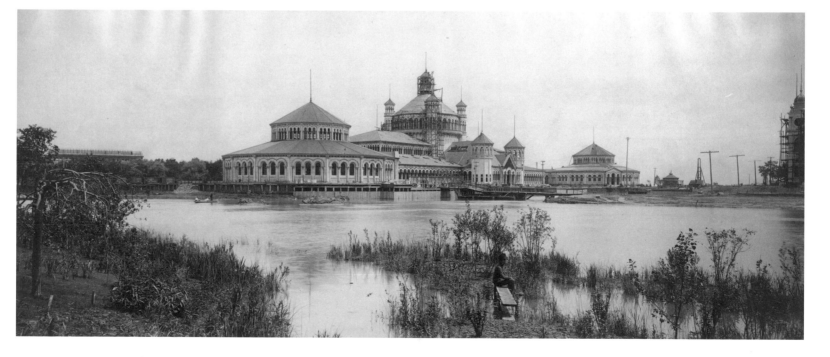

Fig. 29.

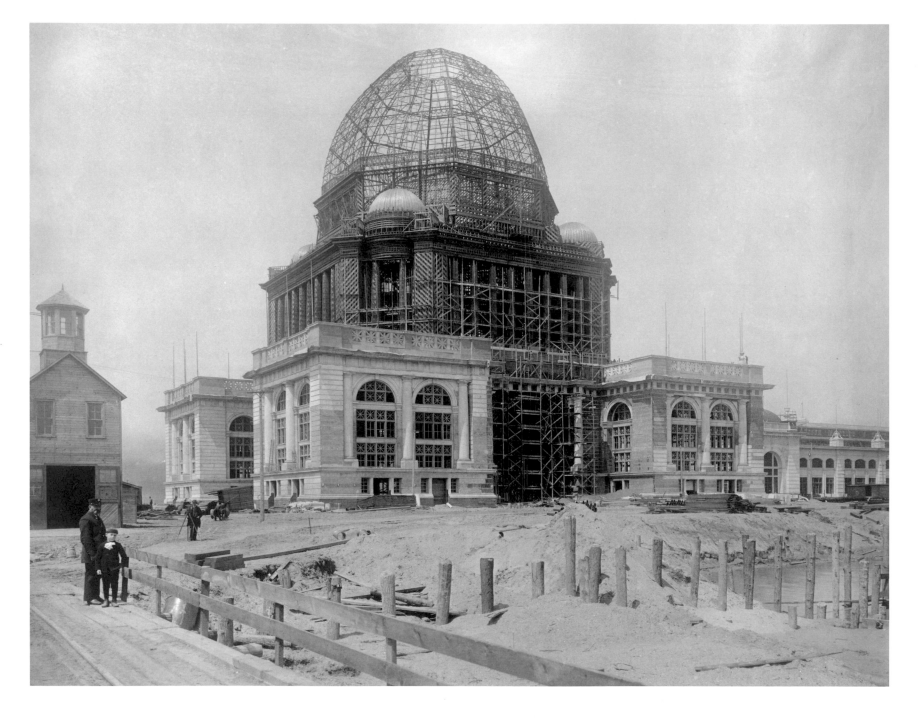

of Machinery rose above a sea of mud and sand. At the south end, the tidy Palladian structure of the Pump House was nearly complete, providing a radical counterpart in scale, in its focus on facade rather than on underlying structure, and in its stage of "progress" from bold engineering to genteel, historicist finality.

By mid-July, Arnold had recognized the usefulness of these visitors to his pictures. Just as the children who had posed in front of the Lagoon in his earliest panorama of exactly a year earlier had served as representatives of innocent potential, and just as the laborers in his later views had symbolized the rough-and-ready masculine comradery of construction, now the well-dressed men and women who posed along the edge of the Basin across from the Agricultural Hall signaled the transition from construction to completion, from action to rhetoric. Even half complete, the buildings were beginning to awe, to impress, to persuade.

Arnold's panorama of that scene, made on July 16, at midday, is one of his very best (fig. 37). Here the resolutely horizontal axis of the panorama worked to special advantage. In the foreground, we see not only the materials of construction (sewer pipes, foundation pilings), but the line between the sterile, sandy soil in its untreated state and the perfectly sodded grass lawn. Above this floats the vast length of Agriculture's facade, still clad in places with scaffolding.

Late July brought a string of spectacular panoramas and mammoth-plate views from Arnold, all of them attempts to record this moment between dynamic construction and grand, static completion. Some of these photographs looked down from above, like the marvelous *380. Mfrs bldg July 23 1892* (see fig. 31), while others, like *381. Administration b'l'd'g July 23. 1892* (see fig. 30), looked across wastelands of dirt, wooden pylons and supports, concrete foundations, and temporary rail lines, at nearly completed buildings whose white cladding of staff already made the structure seem to float, owned by the sky and not the earth.

But perhaps the best of these was his panorama *367. NW. Cor. Art building. July 14. 1892* (fig. 38). This building was unlike all others: built of masonry with a concrete foundation, it was constructed to sur-

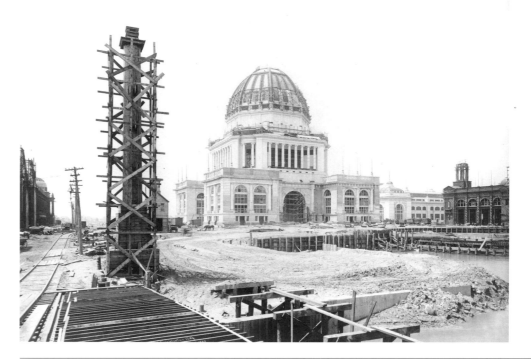

Fig. 30.

vive the Fair. Arnold's view condensed many of his obsessions—the foreground is full of the rough evidences of construction; across the plate's edges we see the early stages of construction, while in the center the finished work gleams forth; and a workman stands in front of the building like a statue, representative of human scale against which the monumentality of the building is to be measured, literally and symbolically. To the right we can see eight plates of staff work waiting to be raised to the facade; on the opposite side of the picture, other still-unfinished bits of ornament lie on the ground in front of the small shed that forms the office of "John Griffiths, Builder." This simple structure, ornamented with his name, exists in contradistinction to the elaborate neoclassical symbolism that adorns (and will adorn) the temple to art that he is building.

Interspersed with these large views are a number of smaller ones, many of them recording the progress of the statuary. These, too, are engrossing, although their formula is simple: they are front-on views of the pieces, in the middle of which we see the sculptor and sometimes his or her assistants. The directness of the view and the counterpoising of these ornate, Canovaesque pieces against the detri-

Fig. 30.

381. Administration b'l'd'g

July 23. 1892.

PRECEDING PAGE

311. Administration b'l'd'g

looking N.W. May 21. 1892.

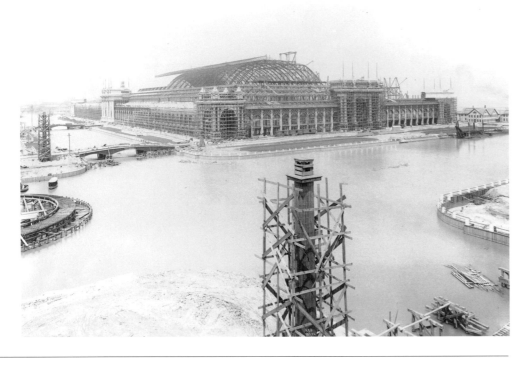

tus of everyday work in plaster give them charm, at least.

By August, Manufactures had reached a construction peak. The three huge railway sheds had been erected, but their massive structural members had not as yet been sheathed, nor the roofs closed in. On the vast open floor, Arnold made three mammoth-plate views. Two described the scale of the interior space (fig. 39). The building was, as the official guidebook trumpeted, "as notable for the symmetry of its proportions as for its immense size." Manufactures and Liberal Arts invited superlatives, and Arnold's views strove to do it justice before its scale was eaten up by internal walls, by whole replica buildings, minarets, spires, clock towers, and an endless string of exhibits of surgical tools, religious artifacts, wool, ivory, "bric-a-brac" furniture, scales, weights and measures, guns, and crucifixes.[27]

Arnold's third view worked in opposite fashion (fig. 40). Rather than exaggerating the open space, Arnold split the frame in two; the right area, filled with the mass of one arch-assembly, showed graphically the nature of the ironwork; the left fled back

into the open space made possible by this triumph of modern engineering, aided by the various wooden beams and supports that followed the diagonal reach of the picture from left foreground into the deep space at the rear.

These were among the last of Arnold's big views of the engineering of the White City, of its endoskeletal structure. Manufactures was about the last building to complete this stage; when it was done, all the focus turned to finish work, and Arnold's pictures began to show the cleaned-up project. There were small pictures of small details, larger views of buildings the photographer had effectively forgotten in his obsession with others—like the Palace of Fine Arts, which finally got a big picture on September 1, 1892.

Then on September 25, Arnold made his last construction view (fig. 41). Dedication was scheduled for October 21, 1892, the date of Columbus's arrival in the New World, and the last weeks involved a frenzy of finish work and landscaping to make the White City presentable, even if it was not in fact near completion or occupation. Arnold's final picture reflected not the haste but the result. It was a mammoth-plate view of a *Bit of East front Horticultural b'l'd'g*, and it was the consummation of sixteen months of work. Arnold's stock formulae for recording construction had finally been rendered unnecessary—everything was done. In the foreground, there was no longer raw dirt nor construction detritus, but weedless, perfect turf, tended by leisurely gardeners, who raked the clippings and put them into wheelbarrows so as not to allow the least imperfection. Above the grass rose the white walls and the glass dome and roofs of Horticultural Hall—itself, of course, the symbol of nature tamed and turned to specimen and servant. Everything seemed perfect; everything awaited the awestruck visitor for whom the entire process had been constructed.

In the oversized albums Arnold and Davis made for a privileged few, construction moves seamlessly from that final mammoth plate, through a series of extremely careful formal views of completed sculpture and then into the official views of the state

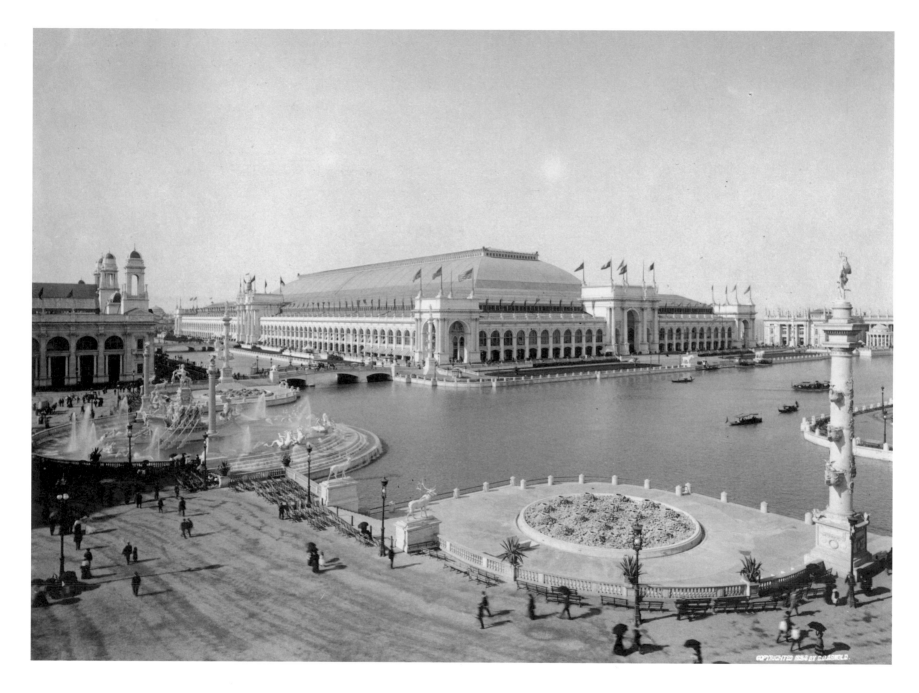

Fig. 32.

buildings, made in the early spring of 1893. Then one turns to the third album in the Art Institute's collection, devoted only to the official views of the White City completed, occupied, fully ready to provide its lessons (figs. 43-46). But the artificial coherence of the albums masks a more complex reality, in which, as Higinbotham's investigative report revealed, not just commemoration but also profit determined the nature of the photographic archive.

The photographs made in the spring and summer of 1892 as rehearsals for the formal set of "official" views may have served as Arnold's evidence that he should be appointed the official photographer of the Exposition proper. It is not entirely clear just when Arnold shifted from being an employee of Director of Works Daniel Burnham to acting as licensed concessionaire under contract. Burnham wrote in his final report that it was "some time before the

Exposition was opened" that "this gentleman became official photographer under a concession agreement...and ceased to be an officer of the staff of the Director of Works."[28] The concession contract records date the official contract sometime after April 20, 1893.[29] And the Photography Department's trial balance sheets record expenditures beginning in March.[30]

But in fact it appears that the administrators of the Exposition had reached an agreement a number of months before, probably during the winter of 1892-93, when there was time enough to consider the complexities of such an arrangement. In any case, the contract continued Arnold's position as a member of the inner circle of Exposition planners, designers, and managers. Unlike the concessions for stereopticon and stereograph views (two highly popular predecessors of the postcard and Viewmaster stereos still featured at

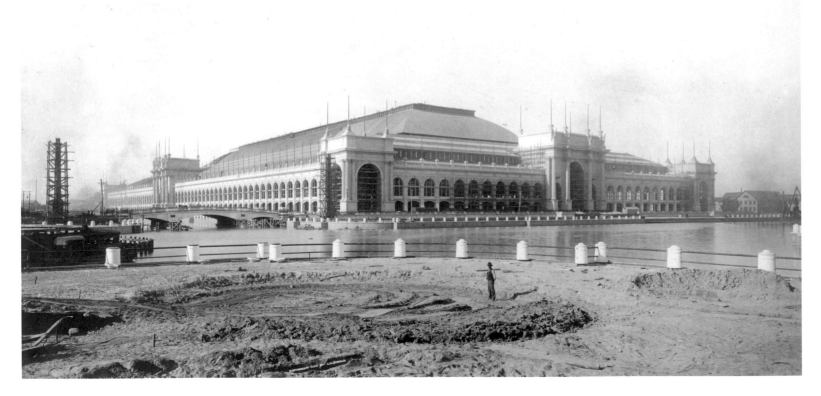

Fig. 33.

431. M'fr's b'l'd'g.

Sept. 1. 1892.

Fig. 34.

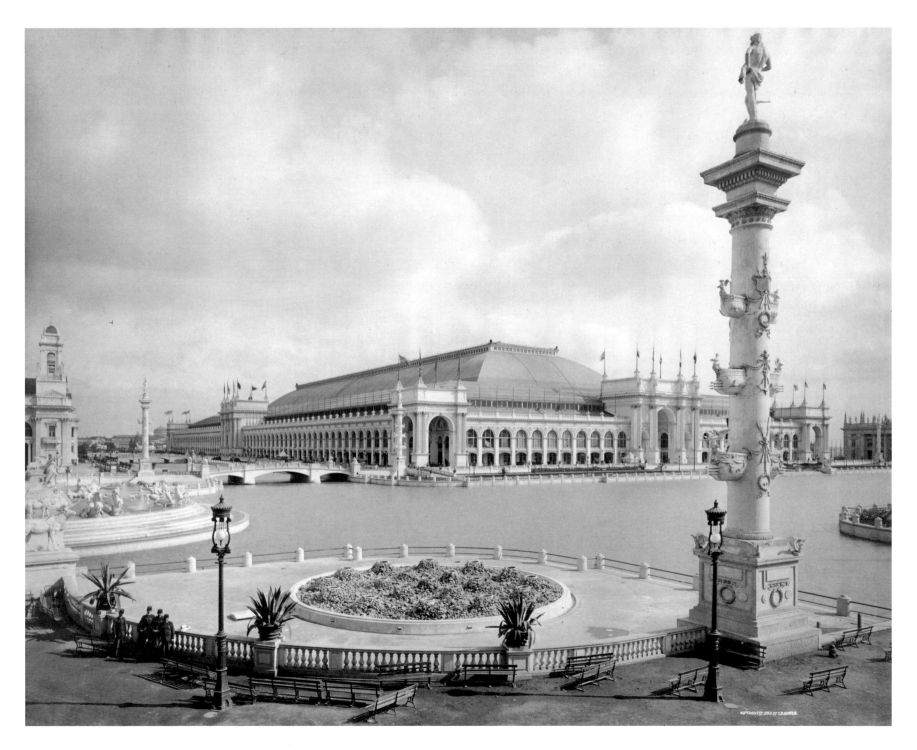

COPYRIGHTED 1893 BY C.D.ARNOLD.

World's Fairs and national park gift shops), and unlike the concession for portraiture (granted to a man who may well have worked as Arnold's assistant during the construction phase), the contract with Arnold made him head of an official department, the Department of Photography. Rather than buying the concession, Arnold was paid to take it—$2,000 per annum plus ten percent of the gross earnings from all photographs sold at the Fair, including the stereos and the portraits, apparently. With his business manager, a Higinbotham family member (further proof that Arnold was a canny businessman!), Arnold now was empowered to create a major commercial enterprise that eventually would employ more than a hundred people (printers, jobbers, retouchers, photographic assistants, salesmen, mounters, framers, janitors), and that netted over $90,000 before Arnold closed it down in 1894.[31]

Arnold devoted most of the fall and winter of 1892-93 to developing this business; in September, he recorded only two employees, but by February, he had thirteen. He had to set up most of the commercial details, including darkroom work, mounting and framing, sales schedules, and the like, before the weather improved. With the arrival of spring he would have to return to a whirlwind of photographing, in order to supply the views he had contracted to produce, not just for sale in the Photography Department itself, but in the form of gravure portfolios for which he had arranged publication so that the results would be available as soon as possible after the opening of the Fair.[32]

And so we turn from the construction of the Fair to its enshrinement, or perhaps its entombment, in the formal views that appeared by the thousands and were reproduced by the millions, throughout the world. In these mammoth views of the completed, occupied (though often unpopulated) Fair, everything is perfect. The weather is always sunny, with an open, transfixing light, full in the shadows, ennobling the spaces and buildings. Above, the clouds give

Manufactures, Electricity,

and Mines buildings.

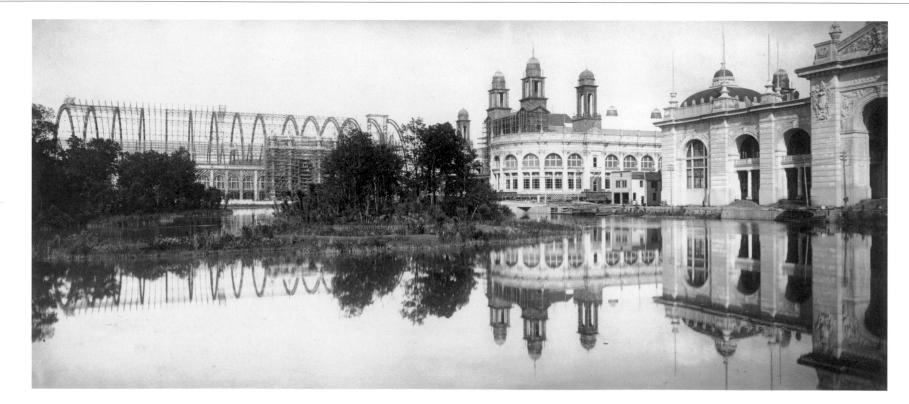

Fig. 35.

sublime character to a sky that presides over the whiteness of an ideal city, although that sky still cannot quite rival the white purity of the buildings and grounds themselves (see fig. 34). The people are usually far away, either because the camera is high atop a building, or because Arnold set up at the edge of a waterway to shoot across it; or because there just aren't many of them, and it appears he was able to marshall the guards to keep people out of exposures. When they do appear in numbers, they may be in the foreground in unusually deep shadow, probably a result of deliberate overprinting or "burning in" to obscure them and particularly their offensive blurring when they walk across the long exposures (fig. 42). Usually, though, the people are props, set there by Arnold and instructed to hold their poses for the one-half to two-second exposure (fig. 46). Figures are often set in postures of observation, while many look back at the camera.

In these views, the Exposition looks disturbingly like the utopian paintings by nineteenth-century American painter and philosopher Thomas Cole—the *Consummation of Empire* from his series *The Course of Empire*, made between 1833 and 1836, and *The Architect's Dream* of 1840. They are references to a European ideal of civilization, seen from the distance of America. In Cole's time, that America was primitive and writhed under its own provincialism. Now in Arnold's day it is an America boldly, even brashly, declaring its maturity, its place on the globe.

The official views reflected upon what the construction views had long ago completed: the construction of the Fair, by which I mean the making of its meaning, its significance. But in construction Arnold had tipped his hand and the hand of his employers, pointing up the way that the Exposition was an attempt to place a new construction on the American city and on the possibilities of an American civilization. In the official views, this same underlying purpose, this urgent desire to prove American preeminence in the modern, was something to suppress. In its place, the pictures—and the

356. Machinery b'l'd'g and pump house looking N.W. July 2. 1892.

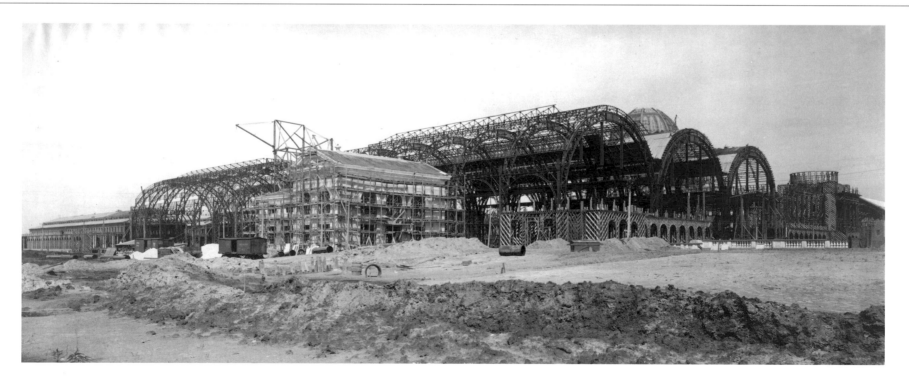

Fig. 36.

35

Fig. 37.

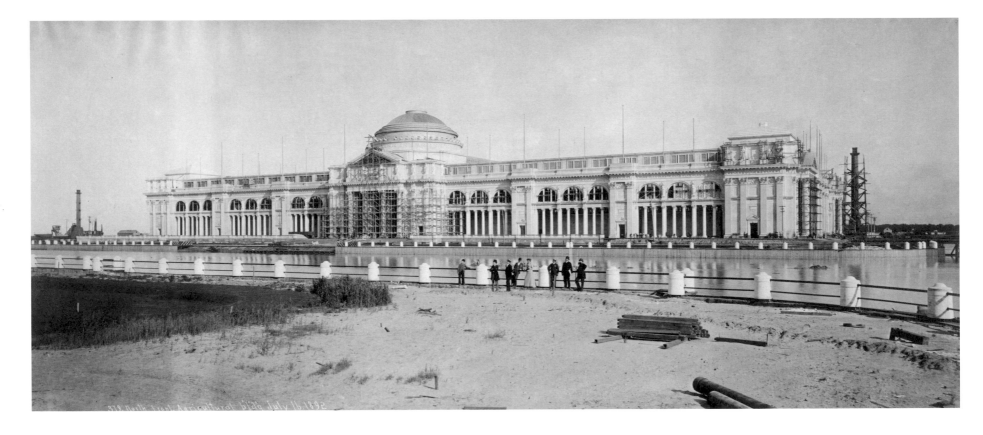

579 North Front Agricultural Bldg July 16 1892

buildings, grounds, and the larger environs (physical and symbolic) in them—became something closer to specimens, pieces of evidence, rather than pleadings.

Partly this was a function of the very different purpose to which the official views were directed, and the very different audience. These were not pictures made solely for an American elite of architects, planners, publishers, newspapermen, reformers, and capitalists. These were aimed at the spectator as well, at the working-class and middle-class consumer and student of the Fair, and they were to communicate its messages of progress, order, faith, obedience, and respect.

If they have, then, a bit of the quality of those illustrations in Bibles received as Sunday School gifts, we can understand it. These views had to be perfect and so they became, in their way, perfectly lifeless, as well. These were honorific views, and they were meant to serve a very different purpose than had the earlier photographs: these were instructions in proper behavior, proper attitudes, proper spectatorship, for the masses of viewers who came to see the Fair, and for the even larger population that could not leave the farm or town or

factory, but wished nonetheless to participate, if indirectly, in the Fair's utopian experience.

In this context, the official views served multiple duties. As fine original platinotypes, they were remembrances to the makers of the Fair themselves. Destined to lose their grandest and most grandiloquent creations in a matter of months (at most, three years), these men and women presented themselves with permanent and, in their own way, equally grand replacements for what would be lost. And they planned, at least, to present similar portfolios to the government of each nation participating in the Fair.

But these views were also intended as commercially marketed mementos of the Fair, for those who had experienced its pleasures and its uplifting messages, and wished the opportunity to savor its lessons repeatedly. In this regard, however, the experiment was a qualified failure. For a number of reasons (including the obscure placement of the Department of Photography's building in a cranny behind Horticulture, far from the points of entry and exit, and also the notoriously unpredictable quality of the souvenir views themselves) photography failed to swamp the market, at least in the form

367. NW. Cor. Art building.

July 14. 1892.

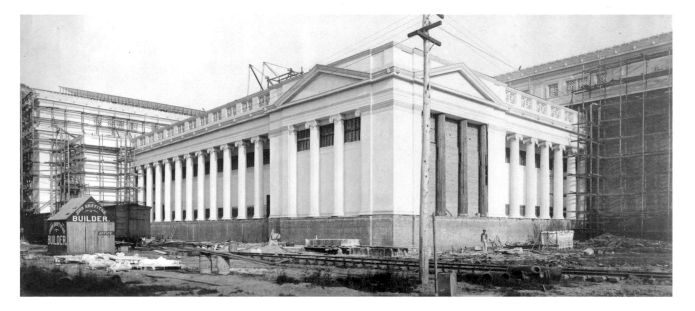

PRECEDING PAGE

379. North front. Agricul-

tural b'l'd'g July 16. 1892.

Fig. 38.

Fig. 39.

413. M'fr's. b'l'd'g.

Aug. 15. 1892.

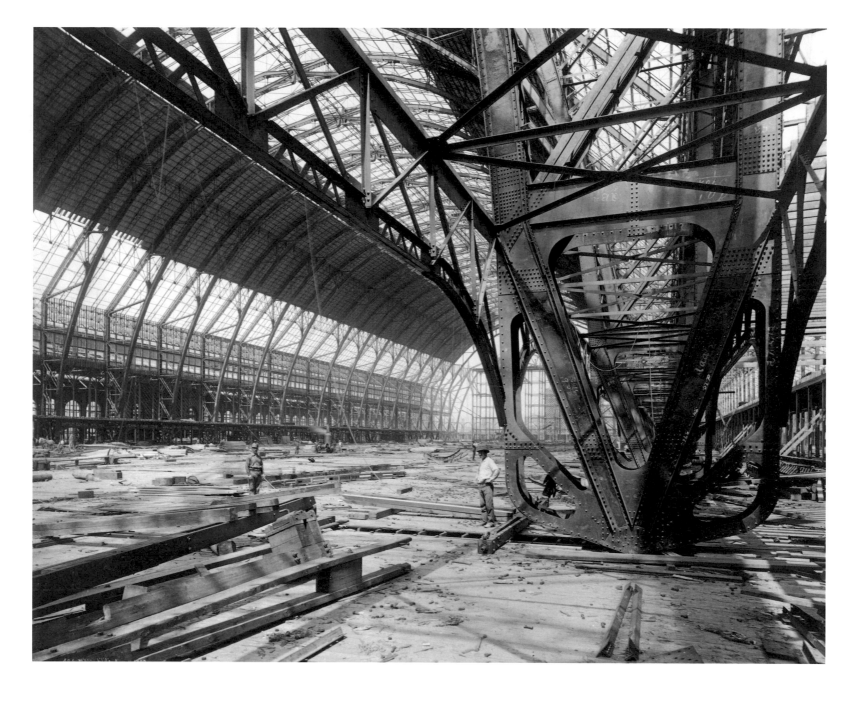

404. M'fr's. b'l'd'g.

Aug. 11. 1892.

Fig. 40.

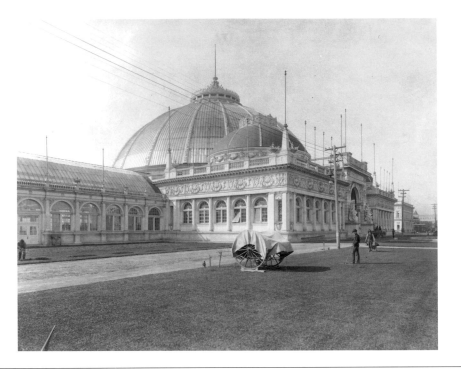

Fig. 41.

umes in the decade before the Fair—the very ones that had helped earn him his original commission as construction photographer.

These Exposition viewbooks were not just commercially successful; they were also ideologically and rhetorically successful. They extended the Exposition's central ideas in a fashion particularly directed at those whom the Fair's controlling elite most hoped to reach—the broad mass of middle-class and working-class Americans who, these social engineers believed, most needed to be instructed in the proper values of civilization, if America was to remain a unified culture and if it was to achieve its destiny (its manifest destiny) as the new imperial presence in a modernized global economy. In no uncertain terms, the captions and slipsheet explanations of Arnold's published views trumpeted the three principles of the Fair: American global preeminence as a capitalist presence; American ascendance, as a result, to the pantheon of civilized nations, and her new importance as a producer of high culture; and (subtly) the responsibility of individual American citizens to embrace the new modern economy and accept their place, however humble, in the vast machinery of American destiny.[34]

Arnold's official views served this function superbly. Their urban sublime viewpoints, their grand-style treatment of space, architecture, and cityscape, their overall presentation of the Fair as the "Dream City" that its planners had hoped it could serve to represent: in all these qualities, the pictures remained central to the public discourse of the Fair, and central to the official attempt to control and dominate that discourse. But they did so largely without Arnold himself present as a participant. In reproduced form, even in the gravure portfolios that were published and marketed by the Department of Photography, Arnold's name seemed less important than the fact that the pictures were official presentations of the official elite. In fact, the more successful the pictures were, the more they seemed to exist on their own, witnesses to grandeur, sublimity, and civility, rather than active creations of it. Their very success lay in Arnold's ability to make them seem mute, even transparent windows onto the real objects of culture: buildings, spaces, landscapes, utopias.

of original prints—though it did manage to sell a total of more than $221,000 in "merchandise," netting Arnold something more than $10,000 in addition to his $2,000 salary.[33]

Where the department flourished, however, was in the portfolios of gravures, the books, and the souvenir volumes that Arnold put together just before, during, and after the Fair. These were immensely popular, and to look at them is to see why. They are far more beautiful and delicate than the rough, now-faded commercial prints Arnold's concession sold alongside them—though they could never come up to the premium-grade platinotypes that were evidently Arnold's métier. Printed by the Chicago Photo-Gravure Company and by Arnold's old printer, New York Photogravure, they are prime examples of the best that the gravure process could offer. Often mounted in "editions de luxe" with leather covers, gold-embossed titles, and tissue slipsheets upon which are printed instructive descriptions of the views, these have all the traces of pretension and seriousness the mundane prints lacked. And they fit quite neatly in the newly popular genre of instructive illustrated views that had come into being with the arrival of the gravure process in the 1880s. Arnold knew the market well, having already produced at least two such vol-

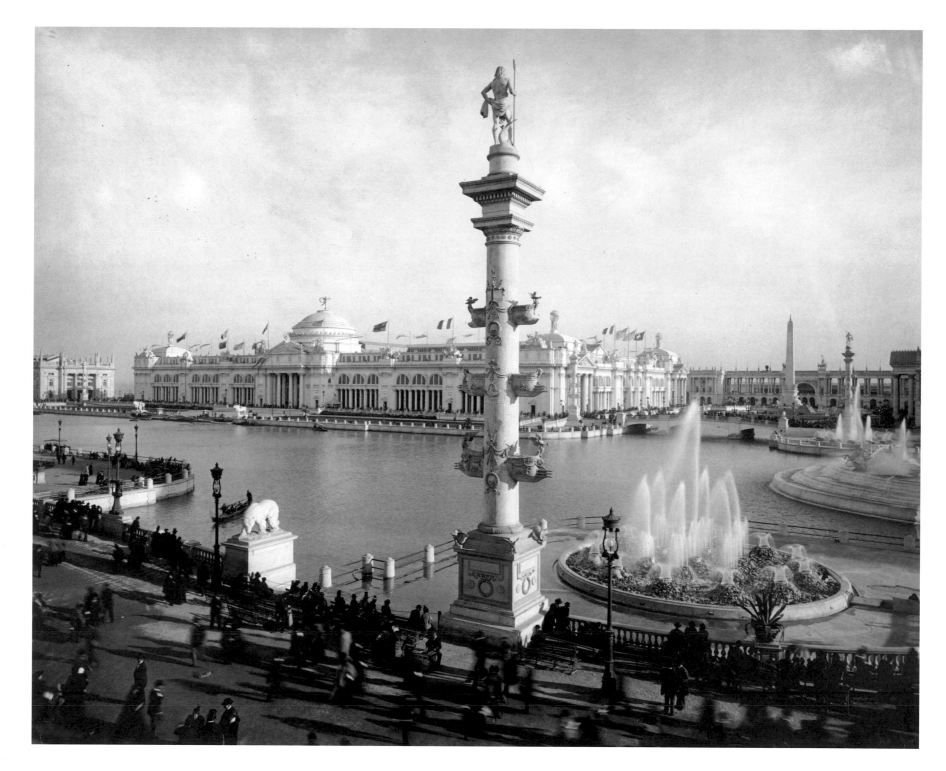

Fig. 42.

Fig. 43.

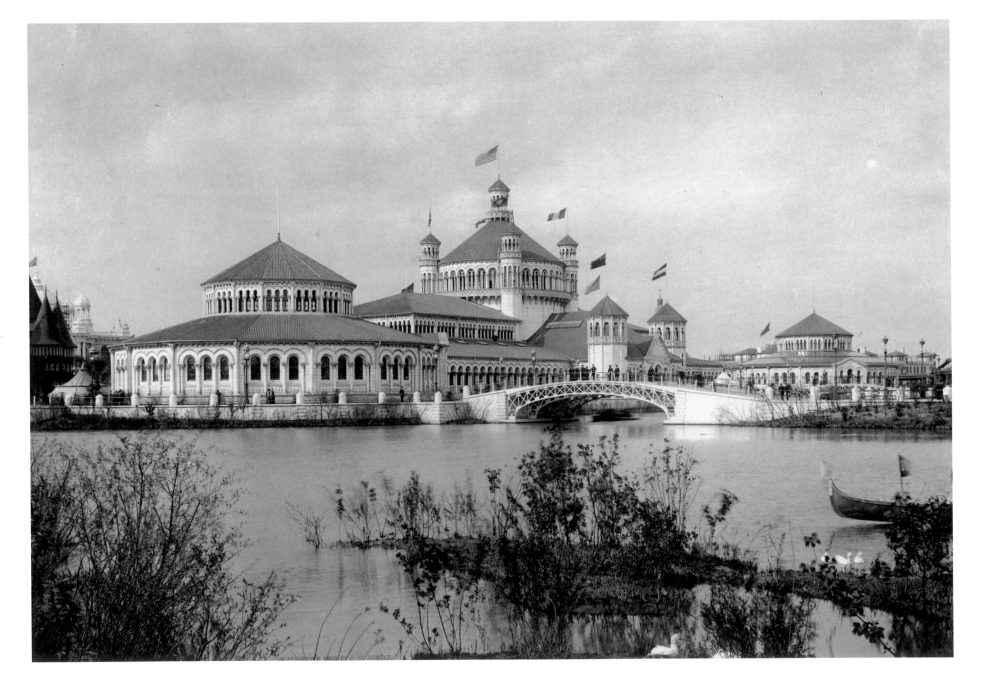

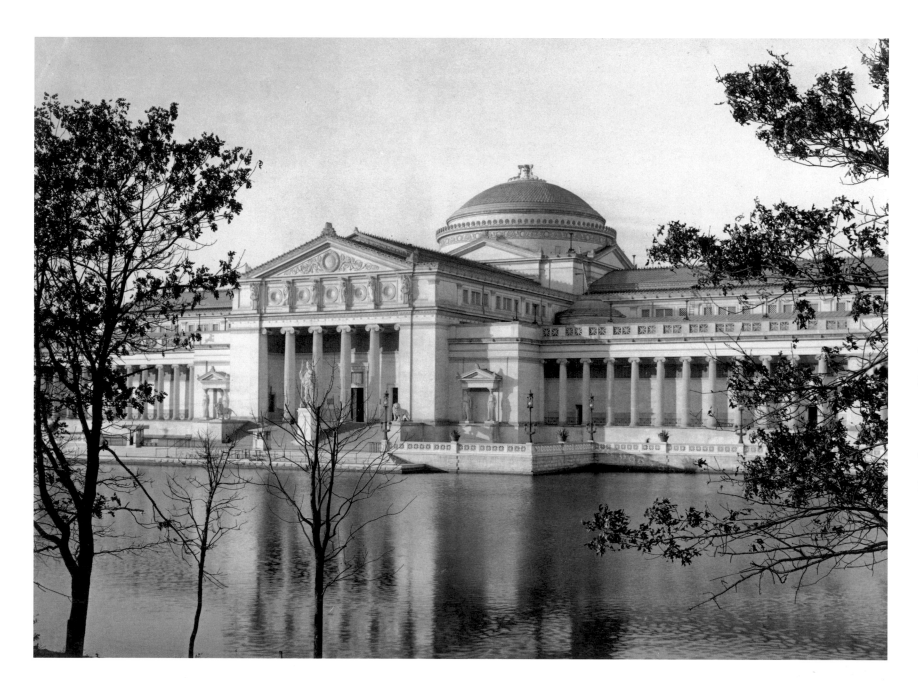

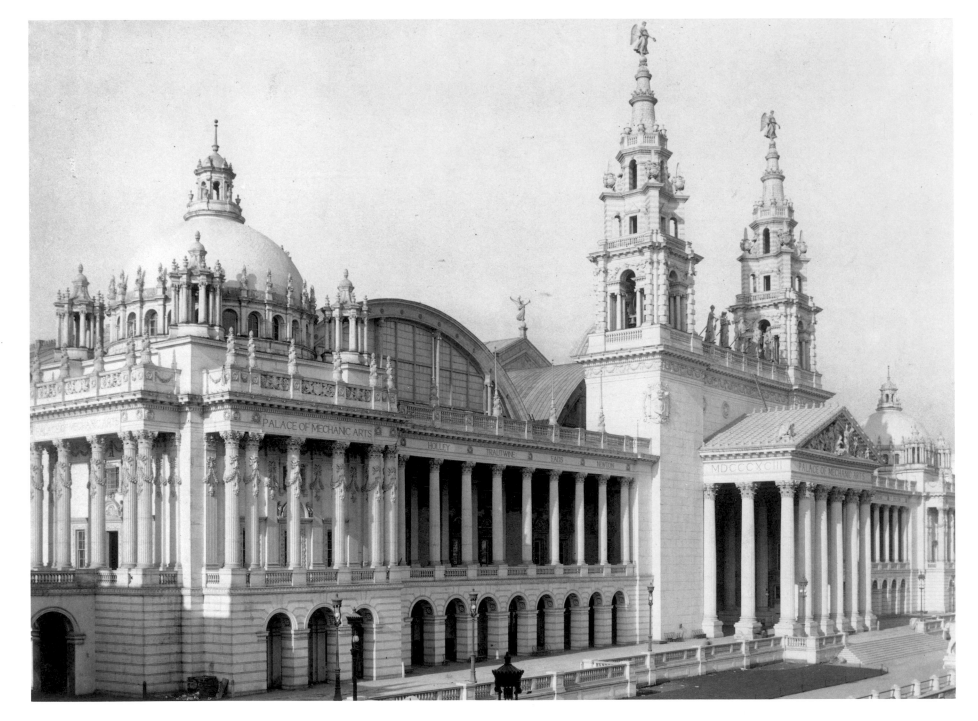

Fig. 45.

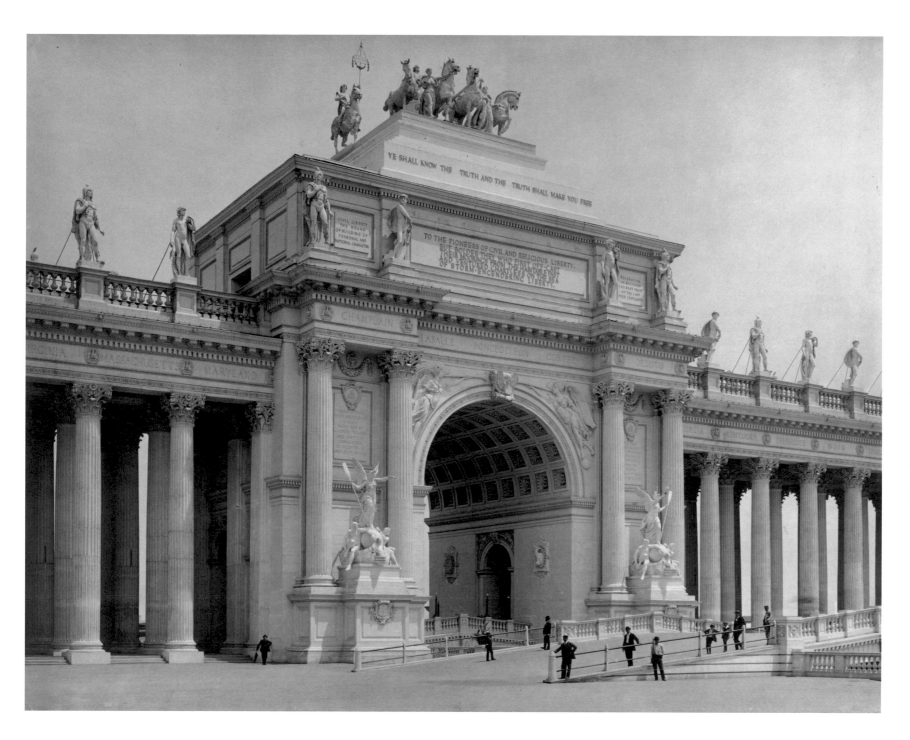

Fig. 46.

Arch of the Peristyle.

PRECEDING PAGE

Machinery Building.

As the Fair wound to a close in the fall of 1893, there remained a last photographic task: the production of a final portfolio of views to be used by Burnham for an official history of the Exposition. But Arnold was not the photographer; he had become embroiled in a dispute over money, credit, and copyright for the photographs, and as a result, Burnham turned to another, the immensely popular landscape photographer William Henry Jackson, for a final set of views of the Fair city.[35]

We shall probably never know the precise nature of the dispute between Arnold and the Fair's planners and administrators. Burnham's papers are mute on the subject; Arnold's papers were long ago lost.[36] The official minutes of various committees and boards are deliberately circumspect. On October 13, 1893, the Board of Directors' minutes recorded that "the attention of the Board was called to the operations of the Bureau of Photography." The matter was referred to the Executive Committee.[37] Three days later, the Executive Committee formed a special subcommittee to investigate "the operations of the photographic concession."[38] The subcommittee never reported back; instead, the Department of Photography presented its estimate for a final portfolio, but the decision was deferred. By that time, Burnham had already commissioned Jackson, and the photographer had made the pictures, submitting a set of a hundred prints to the architect.

By the end of January 1894, the matter was discreetly resolved; Burnham was reimbursed for the Jackson negatives, while the Department of Photography agreed to supply pictures both to the official history and to Burnham and Francis Davis Millet's elaborate history, eventually titled *The Book of the Builders* and sold in serial as an elaborate elephant folio.[39]

The work of constructing the Fair was long over, the work of reconstructing it relegated to another photographer, and it seemed that Arnold's final days would be devoted to supervising the printing of pictures for the official elegies. This alone would have been a daunting task; Burnham wrote that subreports "were requested from the Heads of each Department, covering all of the work of construc-

tion and operation up to November 1st, 1893" and "an extensive selection of photographs was made from negatives of the Official Photographer, in which about 15,000 negatives were carefully looked over for matter to illustrate points on construction, and some 3,000 selections made for further reference."[40] Arnold still had a staff of seventy-seven in October; by December, he had slashed his staff to a quarter of that.[41] Still, twenty workers was a considerable number, easily enough to provide the wealth of prints that eventually went into the multivolume histories and the hand-produced official histories of each department.

But Arnold was not done with the City Beautiful. Some time that winter, he returned to the site, this time to make a series of whole-plate views of the buildings, grounds, and the artwork. Some of these were evidently necessary to fill gaps in the already huge archive. Millet wanted pictures of some of the interior artwork in the domes of the Electricity Building and of statuary in various buildings. Others wanted similarly arcane views.

But interspersed with these are other photographs, more evidently of a piece with Arnold's long epic of utopian dreaming, construction, culmination, and, now, decay and destruction. A view of a portion of the Machinery Building—a back corner—was made in the winter of 1893-94, and its purpose is to show the decline of beauty to tawdry loss (fig. 47). The camera faces the corner squarely; its subject is the ornate dome and, beneath it, the crumbling facade with its white cladding turned to a dirty grey by smoke and pollution from the "Grey City" to the north and west, and the piles of trash in the corner. There is also what may well be one of the makeshift shelters of a "squatter" or "tramp," for whom, in the black Depression of 1893-95, there was no hope of other shelter, or of the work that might pay for it. Perhaps the occupant was one of the thousands of workers who had lived on the grounds during construction, protected from agitators and labor organizers by barbed wire and guards—one of the workers who then lost their livelihoods just at the moment when the Panic plunged into Depression. Or perhaps it is just a storage hut, or an unused trash box, pressed against the rotting wall.

Arnold's last photographs, with their elegiac quality, their undertone of regret, once again echoed the ideals of his employers, the architects and planners of the Fair, and the movers and shakers of the city. His pictures were cut short by the events that accompanied the final end of the White City. On January 1, 1894, the grounds and the buildings thereon were turned over to the South Park Commission, and visitors found the utopian cityscape open to the public for free. The result was a frenzied riot of looting on the first weekend; the *Tribune* headline on January 8 was "Vandals at the Fair: Thousands Despoil Midway of Everything in Sight." The next day, the first of a series of fires, "undoubtedly incendiary" according to the *Tribune*, destroyed the Casino and the Peristyle.[42]

For the privileged of the White City, the fires were disturbing signs of a breakdown in the very urban order that the Dream City had postulated as the utopian future for an industrialized, modernized, imperial America. For men like Higinbotham and Burnham and Lyman J. Gage, the President of the Chicago Board of Directors of the Fair, the victims of the Depression, huddled in the shelter of the Exposition's buildings, became "vicious tramps" (the *Tribune*'s phrase) bent upon destroying this more beautiful and elevated vision.

Nonetheless, the civic elite of Chicago and the White City continued to hope that the Fair might somehow be saved from destruction and serve as a permanent utopia from which the reconstruction of American urban civilization might emanate. But this was a debate devoid of pragmatism—the prohibitive costs of converting temporary staff into permanent, fireproof stone assured that. Over the winter and spring, and into the early summer, the process of piecemeal immolation continued, until finally, on July 5, 1894, a larger fire laid waste to six principal buildings around the Court of Honor, and the debate over how to preserve and make permanent the White City became moot.

The destruction of these major structures lent even more importance to the arena of pictures and visions, whose master was Charles Dudley Arnold. As the physical White City burned down, its supporters and believers of all classes, backgrounds, and relations

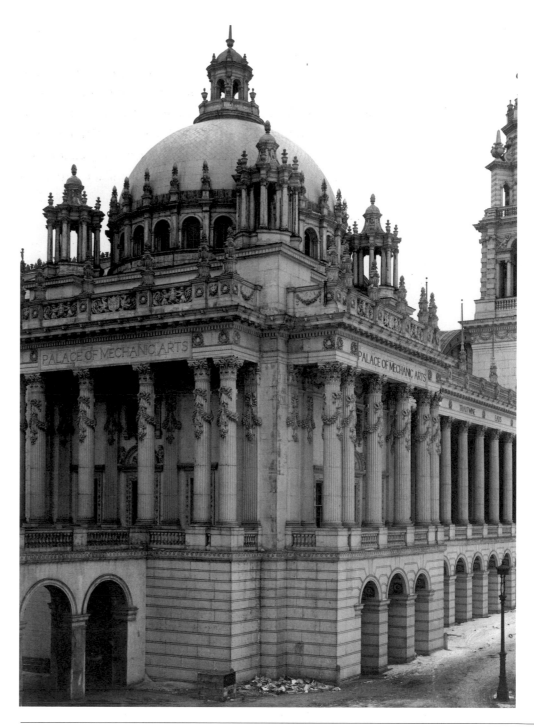

Fig. 47.

Machinery Building,

northeast corner.

with its utopian presence turned with increasing urgency to the construction of a more permanent if more ephemeral Dream City—a city of myth, encapsulated in the official histories, reports, elegies, poems, and photographic albums that the Exposition's financially troubled administration continued to fund with an urgency that was illogical by the logic of capitalism, but inevitable within the logic of desire.

For the Dream City had been built around a fantasy of social and cultural control that could not survive contact with its gritty counterpart. It was a utopia, and as such it survived best not in reality but in myth—a myth that reached its clearest, most perfect, and most persuasive embodiment in the pictures of Charles Dudley Arnold.

For that we are lucky. Today we can go to Jackson Park on the South Side of Chicago and see the remnants of the White City: a broad parkway where once the Midway stood; an overgrown and uneasy park where the outlines of Olmsted's Wooded Isle are barely visible; and even a much-modified version of the Palace of Fine Arts, turned these days into the Museum of Science and Industry, a celebratory paean to the benevolence of American mega-corporations. But in the construction and completion albums that contain the best of Arnold's work, the ineradicable sense of loss is magically contravened. Residents of a later age, we have in Arnold's pictures the means to reconstruct the dreams of a previous era, one that is both alien and familiar to us. We cannot ourselves be transported into the minds of the Dream City's dreamers, nor can we enter the culture of its millions of witnesses. But we can, with care, with respect, use these artifacts of a lost culture to reclaim, if only in small measure, some sense of the utopian dreams of a century past.

Notes

[1] Quoted in *The American Amateur Photographer* 5 (1893), p. 277. At the time, this journal was edited by Alfred Stieglitz, who had developed a near-pathological antipathy for Arnold, and the author of this comment may well have been Stieglitz himself.

[2] The account-books for the Exposition show two paid assistants to the photographer when he moved from construction to concession work—though whether these assistants actually made photographs or worked solely as darkroom technicians and the like is unclear.

[3] Burnham's description of the purpose of the photographs comes from his typescript for the *Final Report of the Director of Works of the World's Columbian Exposition, June, 1894*, vol. 1, p. 24. Burnham's complete eight-volume report is held in the Burnham Collection of the Ryerson and Burnham Libraries at The Art Institute of Chicago.

[4] The article in the *Buffalo Courier* is included in a clippings file held by the Ryerson and Burnham Libraries of The Art Institute of Chicago.

[5] These calculations are based upon informed speculation: the Fair had 27 million paid admissions, but many made multiple-day excursions (the guidebooks told visitors to allow at least four days). Using a sample of visitors drawn from attendance documents, reminiscences and letters, and the like has led me to estimate attendance at 10 to 15 million. Of the guidebooks and viewbooks, souvenirs and the like, the number is based upon a pass-through ratio of 4 to 1, conservative for the nineteenth century, I think, where printed and published matter was highly prized and liberally shared around.

[6] As boxed presentation sets, Arnold's photographs were to have been offered to every major nation on the globe. There is, however, no immediate evidence that these "state portfolios" were ever made.

[7] Hubert Howe Bancroft, *The Book of the Fair*, 2 vols. (Chicago and San Francisco, 1893, 1895), title page of vol. 1. The cultural history of the World's Columbian Exposition has recently received a number of happy additions. Perhaps the most concise and rewarding work is Alan Trachtenberg's chapter on the Fair in *The Incorporation of America: Culture and Society in the Gilded Age* (New York: Ticknor and Fields, 1982); a longer and more discursive study is James Gilbert, *Perfect Cities: Chicago's Utopias of 1893* (Chicago: University of Chicago Press, 1991); two book-length studies are R. Reid Badger, *The Great American Fair: The World's Columbian Exposition and American Culture* (Chicago: N. Hall, 1979) and David F. Burg, *Chicago's White City of 1893* (Lexington: University Press of Kentucky, 1976). I have written at some length about the imagery of the White City in *Silver Cities: The Photography of American Urbanization, 1839-1915* (Philadelphia: Temple University Press, 1984), *William Henry Jackson and the Transformation of the American Landscape* (Philadelphia: Temple University Press, 1988), and "Photography and the World's Columbian Exposition: A Case Study," *Journal of Urban History* 15, no. 3 (May 1989), pp. 247-73. Julie K. Brown has recently completed a study of the photographic imagery of the World's Fair, *Contesting Images: Photography at the World's Columbian Exposition, Chicago, 1893* (Tucson: University of Arizona Press, 1993).

[8] Davis's speech is quoted in Ben C. Truman's *History of the World's Fair: Being a Complete and Authentic Description of the Columbian Exposition from its Inception* (Philadelphia: H. W. Kelley, 1893), p. 96.

[9] H. H. Van Meter, *The Vanishing Fair* (Chicago: The Literary Art Co., 1894).

[10] The official documents report 27 million paid admissions; the number of actual visitors is harder to determine. My estimate is drawn from sampling visitor lists to determine the average length of stay and the number of visits made by each visitor. On the way visitors treated the Fair, see Gilbert (note 7), pp. 75-77 and passim; Gilbert has also written that "perhaps a tenth of the American population packed its bags and caught the train for a pilgrimage to… the shining white city of the World's Columbian Exposition" (p. 1).

[11] Quoted in Gilbert (note 7), p. 90.

[12] Clarence Day, *Life With Father* (New York, 1935).

[13] As quoted by Burnham in his *Final Report* (note 3), vol. 1, p. 48.

[14] The gravure appears in *The Inland Architect and Builder* 5, no. 6 (July 1885); it is credited as an "Inland Architect and Builder Phototype."

[15] See Hales, *Silver Cities* (note 7), pp. 112-15; architectural historian Arnold Lewis has also written of the importance of photography to the marketplace of American architecture during the 1880s; see Arnold Lewis and Keith Morgan, eds., *American Victorian Architecture* (New York, 1975), pp. 1-6, 14-15. Both the *American Architect and Building News* and the *Inland Architect* began publication concurrently with the availability of gravure reproduction of photographs; the *American Architect* began using gravures in 1886, replacing or supplanting earlier "heliotype" gelatine prints; the *Inland*, however, had never used the earlier photoreproduction process. Mary Norman Woods, in *The American Architect and Building News, 1876-1907* (Ph.D. diss., Columbia University, 1983), pp. 169-261, devotes a detailed chapter to the use of photo-reproduction technologies to the dissemination of architectural views.

[16] Charles Dudley Arnold, *Studies in Architecture at Home and Abroad* (New York: The Photogravure Company, 1881, 1888; also Troy, New York: Nims and Knight, 1888). Arnold's obituaries, along with a profile of the photographer from the *Buffalo Courier* (August 9, 1898), are in the collections of the Ryerson and Burnham Libraries at The Art Institute of Chicago.

[17] Burnham, *Final Report* (note 3), vol. 1, p. 24.

[18] Moses Handy, "Department of Publicity and Promotion," reprinted in Rossiter Johnson, ed., *A History of the World's Columbian Exposition Held in Chicago in 1893* (New York: D. Appleton and Co., 1897), Vol. II, pp. 1-31.

[19] Ibid. On the spaces occupied by Photography, see Burnham, *Final Report* (note 3), vol. 1, pp. 54, 64.

[20] Minutes, Council of Administration, Tuesday, April 18, 1893, in Chicago Historical Society Manuscripts Collection, bound volume 47, pp. 269-71.

[21] Arnold engaged here in a radical reductionism that looks, to modern eyes, like the minimalist exercises of New Topographics photographers in the 1970s.

[22] This strategy is discussed at some length in Hales (note 7), pp. 69-130, esp. pp. 73-96.

[23] See, for example, his view of wheelbarrow laborers, *84. Site of Art Building looking North Oct. 22, 1891.* The exception to this rule is found in the views of artists at work on the early models for the ornamentation and statuary. But this, I think, represents a different case; these were members of the elite who invented and defined the Exposition. They were, more or less, Arnold's employers—certainly they were his "betters." Indeed, after March of 1892, even the artists look different; it's hard to distinguish them from their assistants—especially in the whole-plate pictures like 278 and 279, made on April 13, 1892.

[24] John J. Flinn, *Official Guide of the World's Columbian Exposition…*(Chicago: The Columbian Guide Company, 1893), p. 43.

[25] On March 31, 1892, Burnham wrote to his wife from the grounds: "I am at the Park and Mr. Howe is here with the boys [Daniel Hudson, Jr., age ten, and Hubert, age six]. They are very happy to be here and are now looking at the large photographic album with Mr. Geraldine. Mr. Arnold is going to show some pictures so they will have a good time. I wish you were here to see them all." The letter is found in the Burnham Collection of the Ryerson and Burnham Libraries of The Art Institute of Chicago.

[26] *Official World's Fair Guide, Map and Directory, During Construction* (Chicago: Department of Publicity and Promotion, World's Columbian Exposition, July, 1892). Arnold made a picture of the 63rd Street turnstile on July 5, 1892, and it is apparently in service.

[27] Flinn (note 24), p. 91.

[28] Burnham, *Final Report* (note 3), vol. 1, p. 24.

[29] *World's Columbian Exposition. Concession Agreements. Vol. VI.—Nos. 101 to 120. 19th January, 1893 to 21st April, 1893* (Chicago: Auditor's Office, 1893). Each contract was published by Chicago Legal News Company; an incomplete set is held by the Chicago Historical Society.

[30] See the typescripts of the Department of Photography's Trial Balance Sheets, in the Palmer Collection, Chicago Historical Society Manuscripts. These sheets began on March 31, 1893, and listed the month's payment of $5,638.16 from the World's Columbian Exposition, $5,168.46 paid in "purchased merchandise," $1,102.25 paid in from the "Construction Account," and charges of $5,637.35 for "Apparatus and Material" and salaries of $4,874.99.

[31] Harlow N. Higinbotham, *Report of the President to the Board of Directors of the World's Columbian Exposition, Chicago, 1892-1893* (Chicago: Rand McNally and Co., 1898), "Appendix B: Statement of Force Employed by World's Columbian Exposition, September 1892 to October, 1893, inclusive," pp. 337-38, and "Appendix C: Report of the Auditor," p. 340.

[32] Ibid.

[33] Copy of the agreement [i.e. the legal contract cited above] between C. D. Arnold and Harlow D. Higinbotham, *Right to establish a bureau of photography and make and sell photographs of the grounds and buildings of the World's Columbian Exposition* (Chicago: Chicago Legal News Company, 1893); see Higinbotham (note 31), "Appendix C: Report of the Auditor," pp. 339-41. If Julie K. Brown (note 7) is correct in saying that Arnold also got a percentage of the Kilburn and Davis stereo receipts, his total would have reached closer to $20,000.

[34] This triple message has been the subject of a number of important historical studies. Perhaps most important is Trachtenberg (note 7); see also Gilbert (note 7). Both the earlier treatments of the culture of the Fair, Badger (note 7) and Burg (note 7), also focus on this issue.

[35] See Hales,*William Henry Jackson* (note 7).

[36] Burnham's papers are held in the Ryerson and Burnham Libraries of the Art Institute. A number of scholars and archivists have sought the Arnold papers without success.

[37] Minutes of the Board of Directors, bound handwritten albums held in the Manuscripts Collection of the Chicago Historical Society, October 13, 1893, meeting, volume 44, p. 861.

[38] Minutes of the Executive Committee, vol. 35, p. 985.

[39] Minutes of the Executive Committee, January 10, 1894, vol. 36, pp. 1066-67. The entire passage gives some idea of the circumspect nature of the dispute and its handling:

"The Chairman called the attention of the Committee to an arrangement which he had made with D. H. Burnham relative to the Department of Photography of the Exposition furnishing that gentleman and his associates with such photographs as they might require in order that their proposed story of the Exposition [presumably *The Book of the Builders*] might be properly illustrated; the arrangement being that the Department of Photography should furnish the photographs called for, the same to be charged to the World's Columbian Exposition, bills to be rendered to the Auditor, a copy to be sent to Mr. Burnham to be checked by him and returned to said Department, and also providing that the so-called 'Jackson Negatives' which had been in the possession of Mr. Burnham be turned over to the Department named.

"It was moved by Mr. Waller and seconded by Mr. Walkers, that the action of the President be concurred in and endorsed.

"Mr. Keith offered as an amendment that the expense to be incurred by the Exposition should not exceed the sum of $1,000."

[40] Burnham, *Final Report* (note 3), vol. 1, p. 96

[41] See the Trial Balance Sheets (note 30).

[42] *Chicago Tribune* articles are found in scrapbooks in the library of the Chicago Historical Society.